Creatopia
A COLORING BOOK

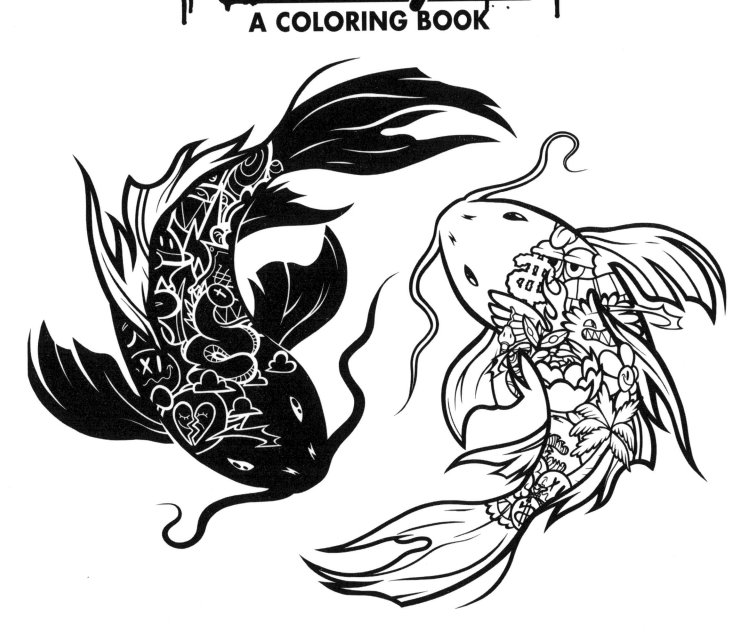

VEXX

A TARCHERPERIGEE BOOK

tarcherperigee

An imprint of Penguin Random House LLC

penguinrandomhouse.com

Library of Congress Cataloging-in-Publication Data

Names: Vexx, author.
Title: Creatopia / Vexx.
Description: New York: TarcherPerigee, Penguin Random House LLC, [2020] I
Series: Art by Vexx
Identifiers: LCCN 2020030484 I ISBN 9780593330302 (paperback)
Subjects: LCSH: Coloring books. I Animals in art.
Classification: LCC NC965.9 .V49 2020 I DDC 704.9/432—dc23
LC record available at https://lccn.loc.gov/2020030484

Printed in the United States of America

8th Printing

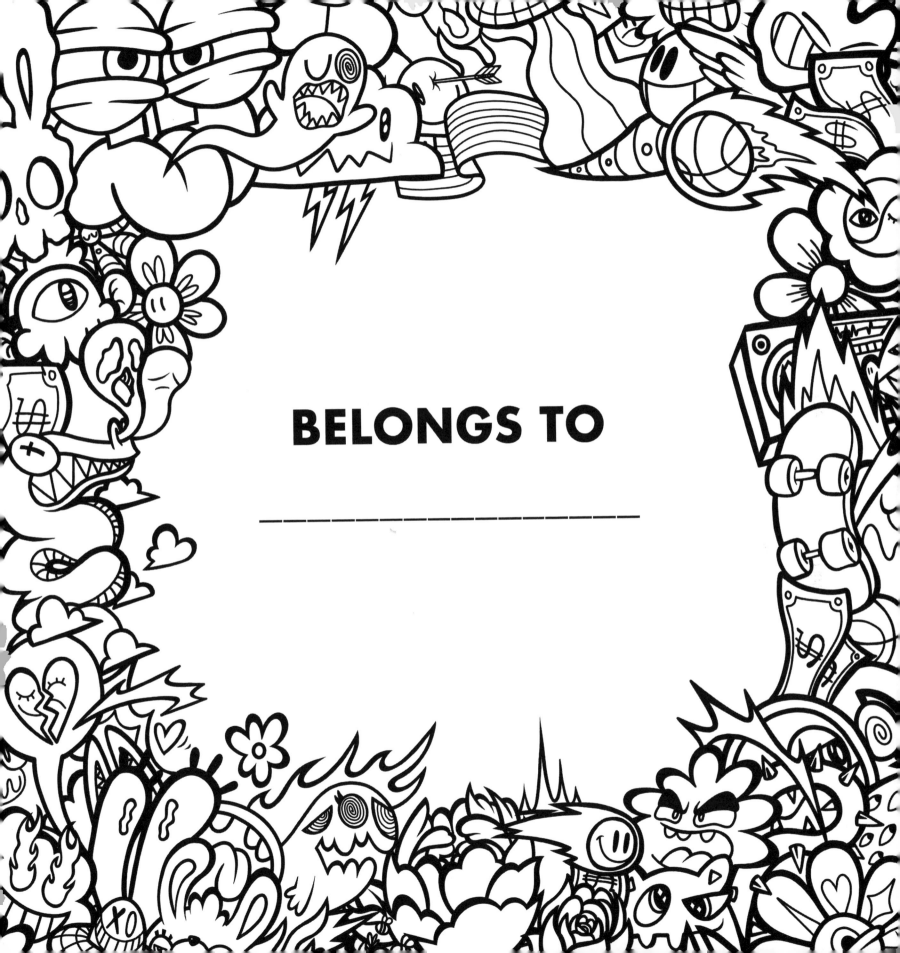

BELONGS TO

WELCOME TO THE WONDERFUL WORLD OF

Get lost in the details of these illustrations.

In the following pages, you'll find dozens of super-detailed creatures combined with inspiring doodle art. Making this book has been a crazy journey. For the past four years, people have been asking me to make a coloring book, and it took this long to finally make it happen.

My purpose for this book is to inspire you to create. That's the biggest piece of advice I want to pass on. Create!

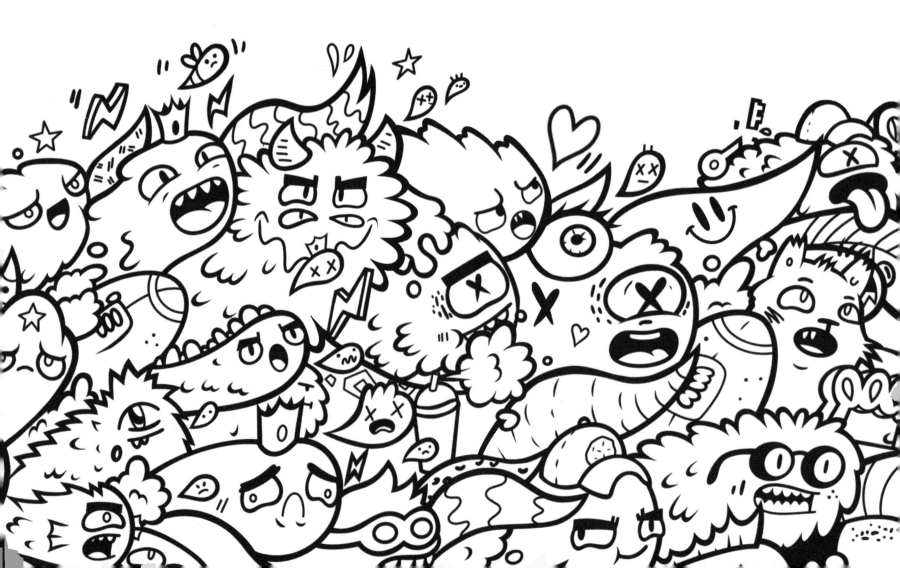

I have found that people are happiest when they're creating. Not only creating art, but also creating memories, creating songs, creating bonds with friends, creating moments.

That's why I included not only coloring pages, but also collaboration pieces that you can fill with your own original creations in order to complete the artwork. I've also added some fan-favorite full doodle pages at the back, so there is something for everyone.

Every page can be colored any way you like.

Tip: If you're using markers, add some scrap paper behind the page you're working on so the ink doesn't bleed through the page onto the next drawing.

Get inspired by the world, and allow the world to be inspired by you. Thank you for taking this journey with me. I can't wait to see your creations! Tag @Vexx and use #Creatopia.

—VEXX

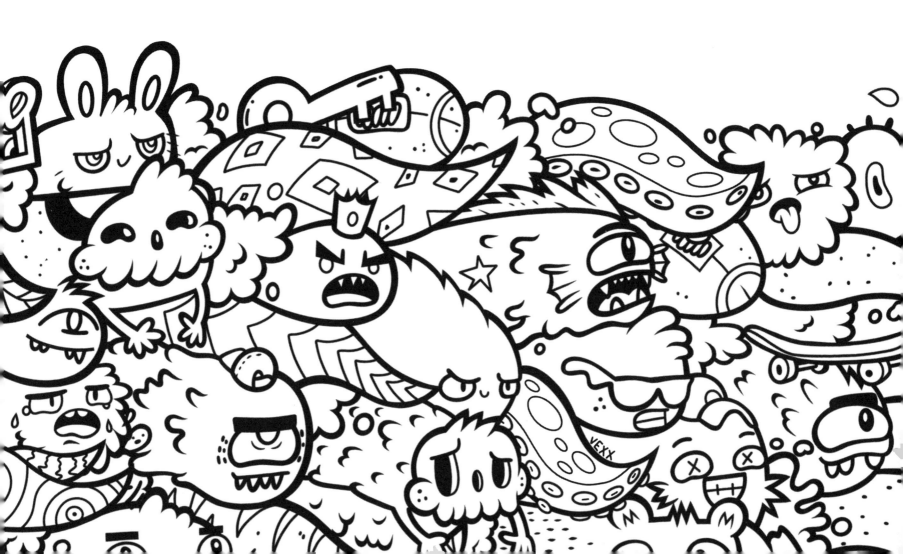

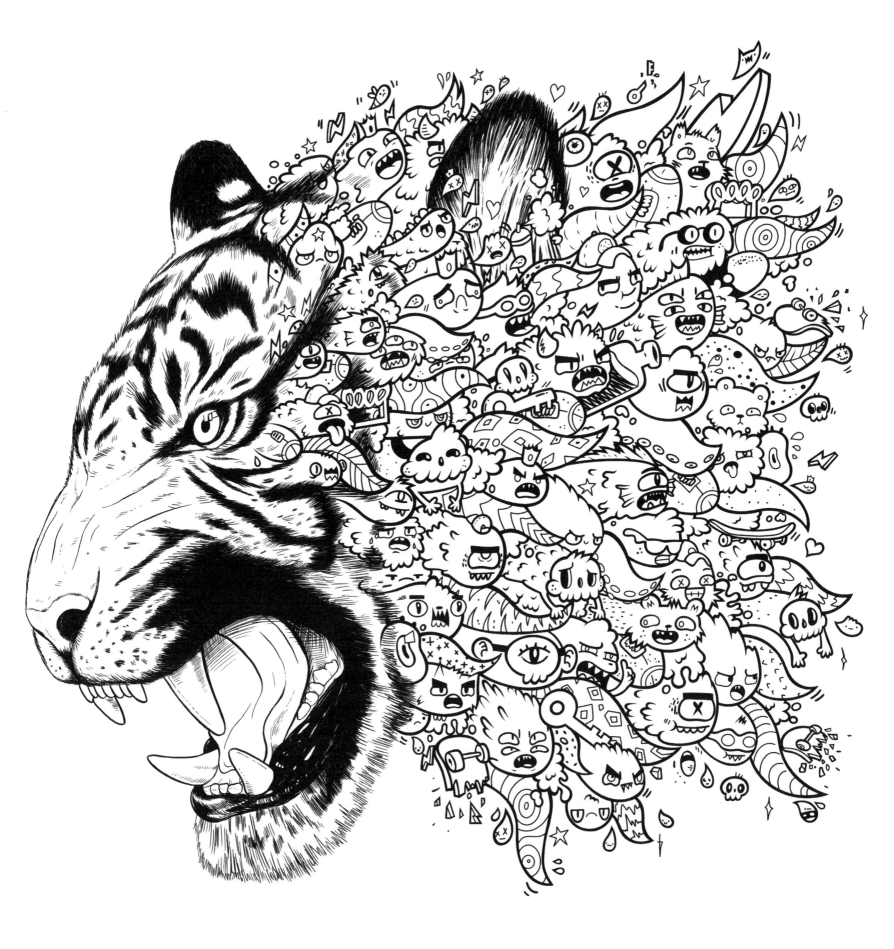

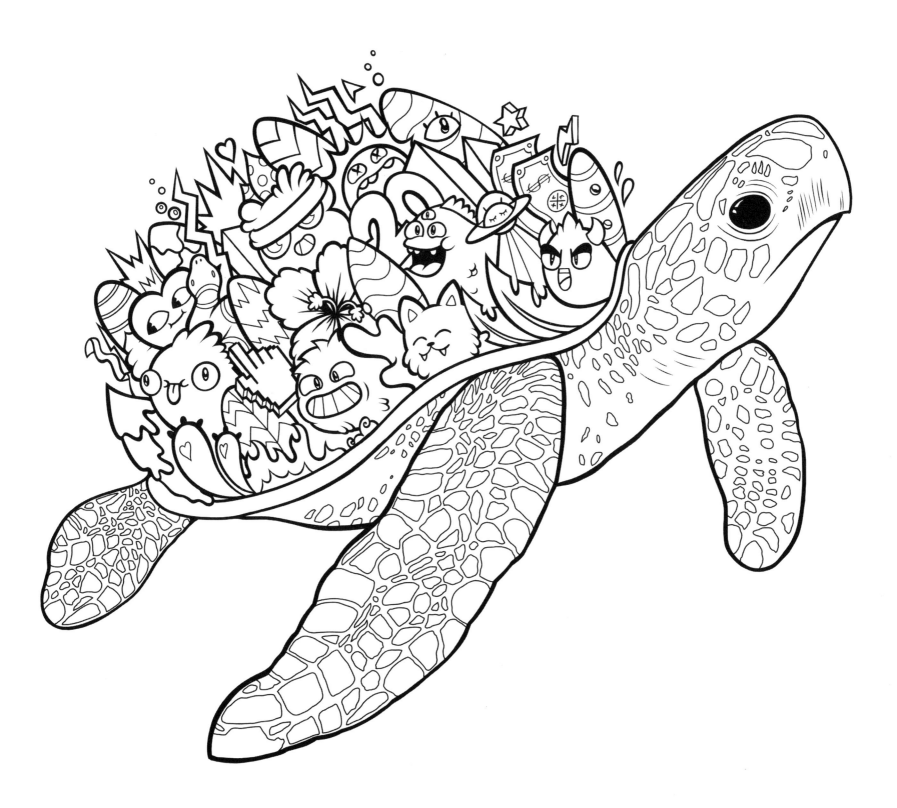

Complete the empty butterfly wing with your own doodles.

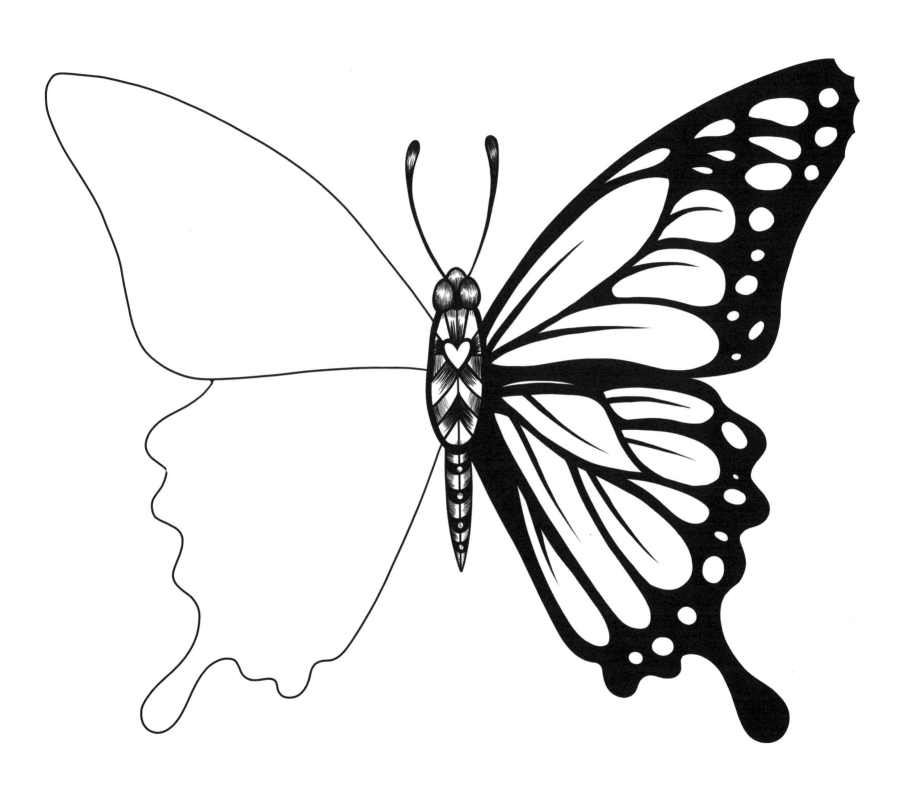

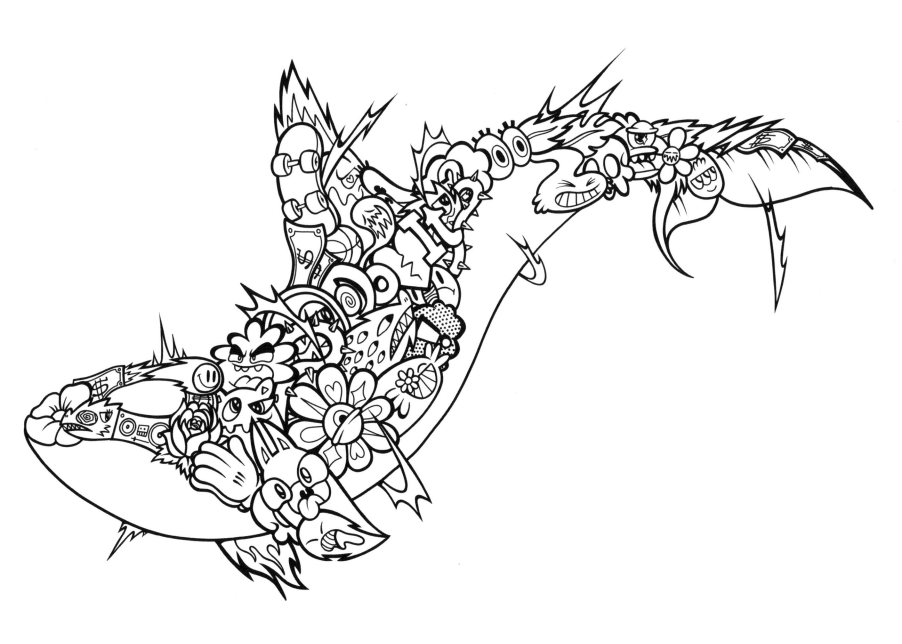

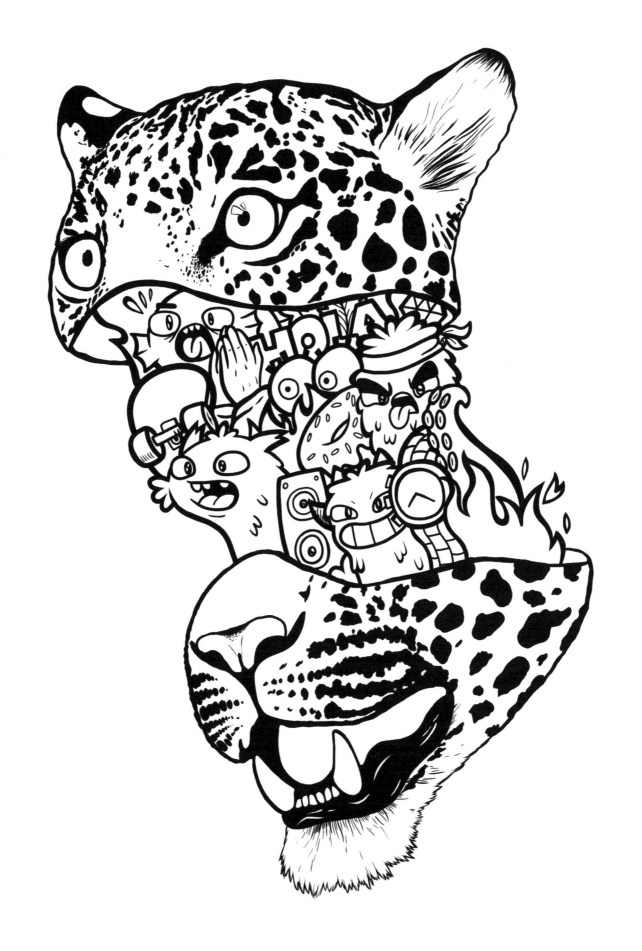

Doodle in the tentacles.

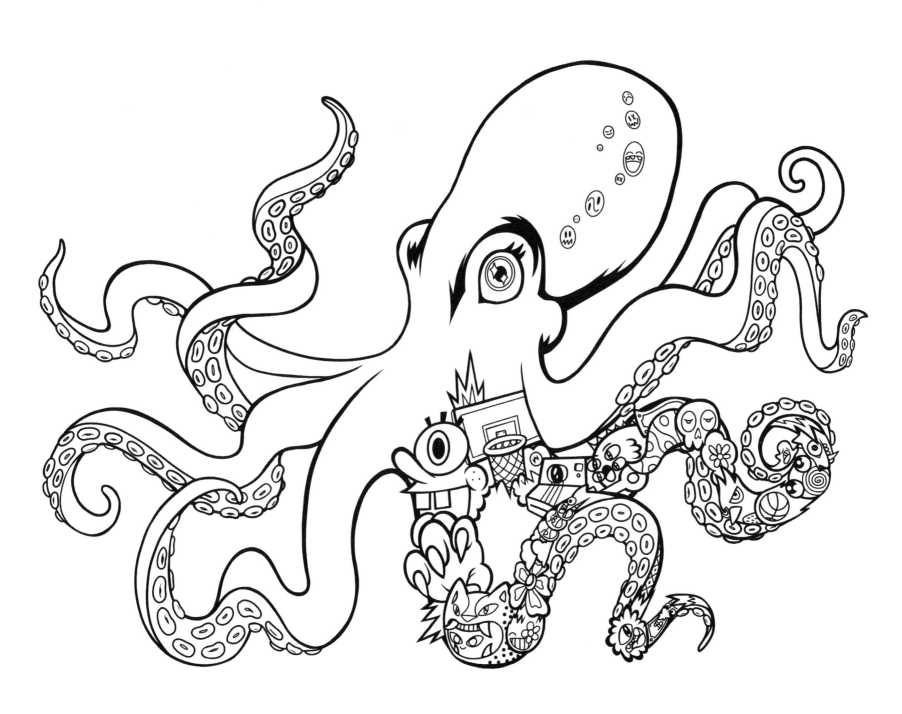

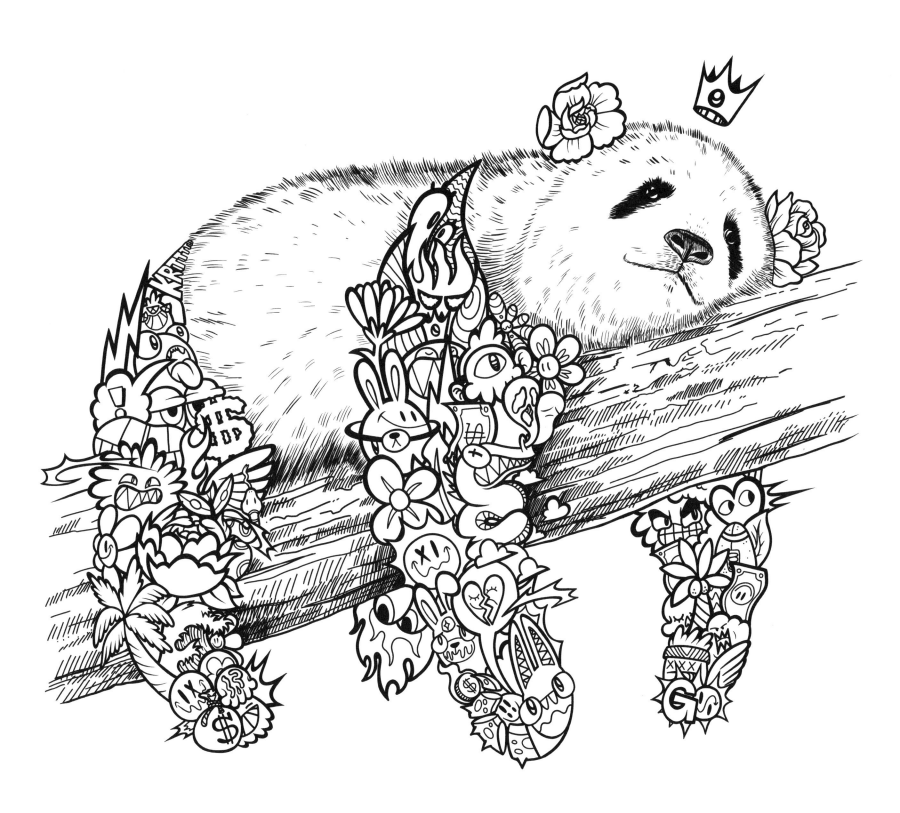

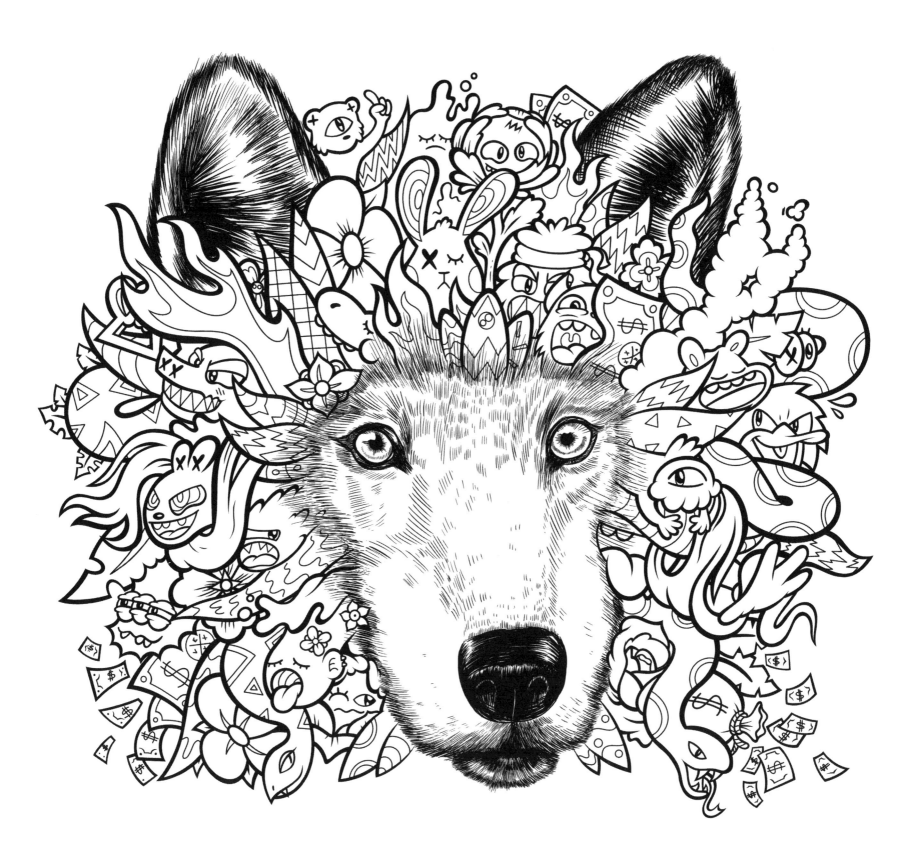

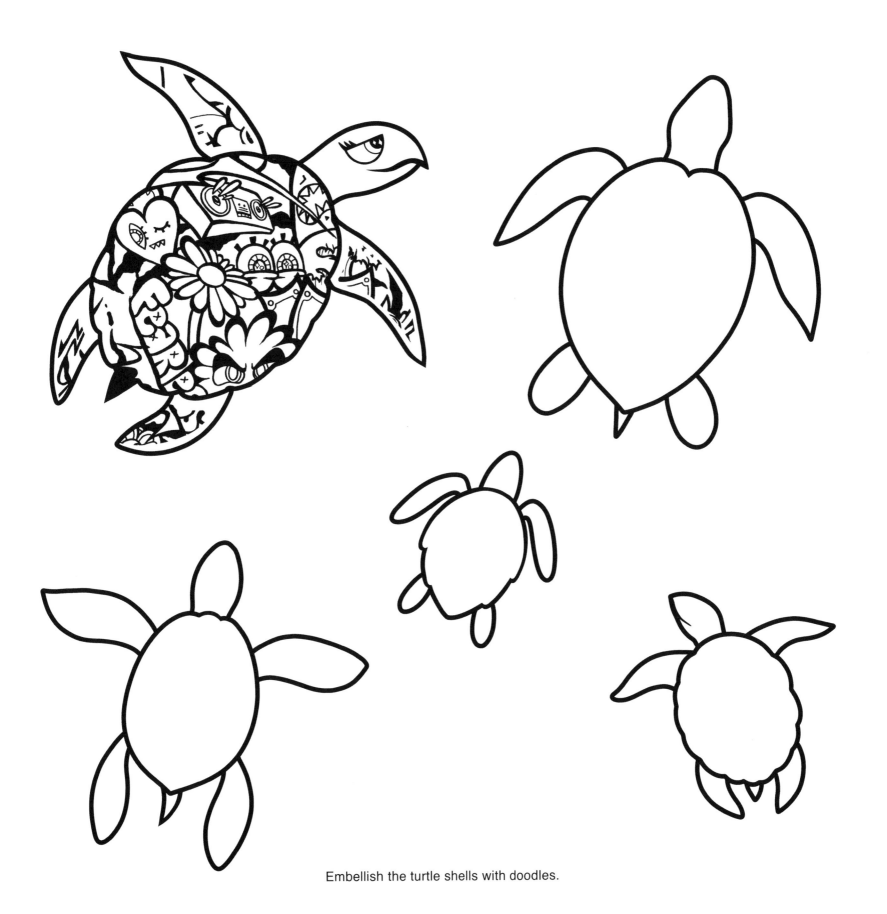

Embellish the turtle shells with doodles.

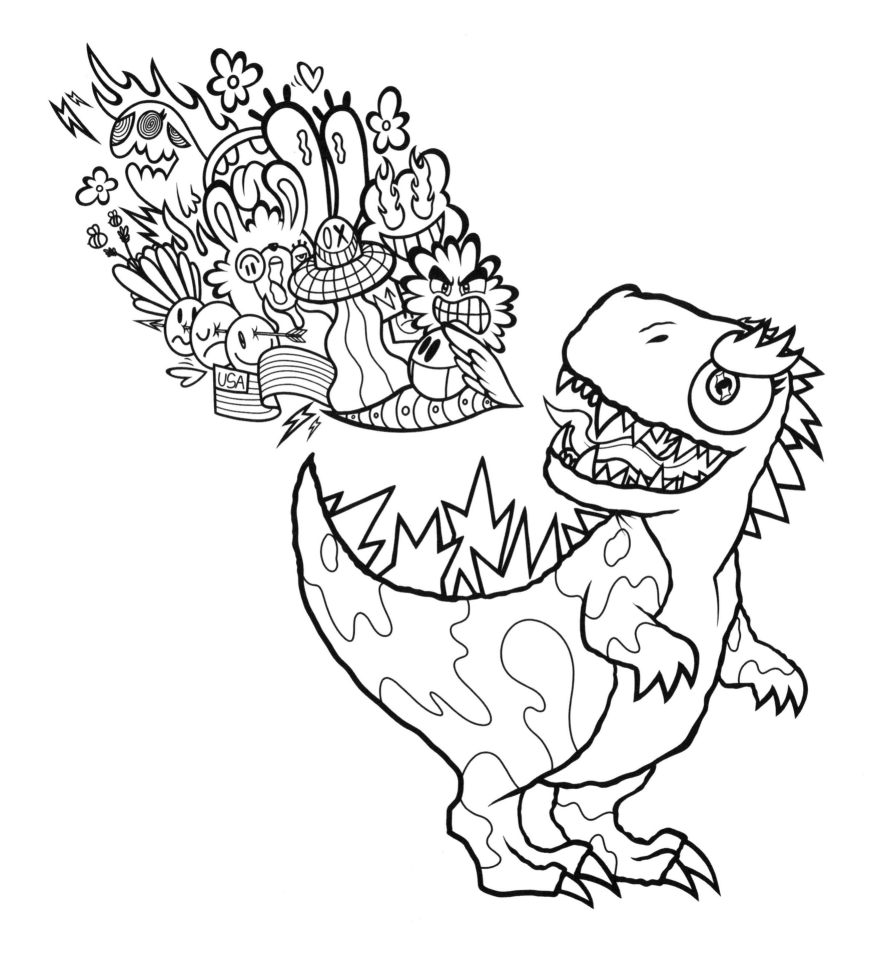

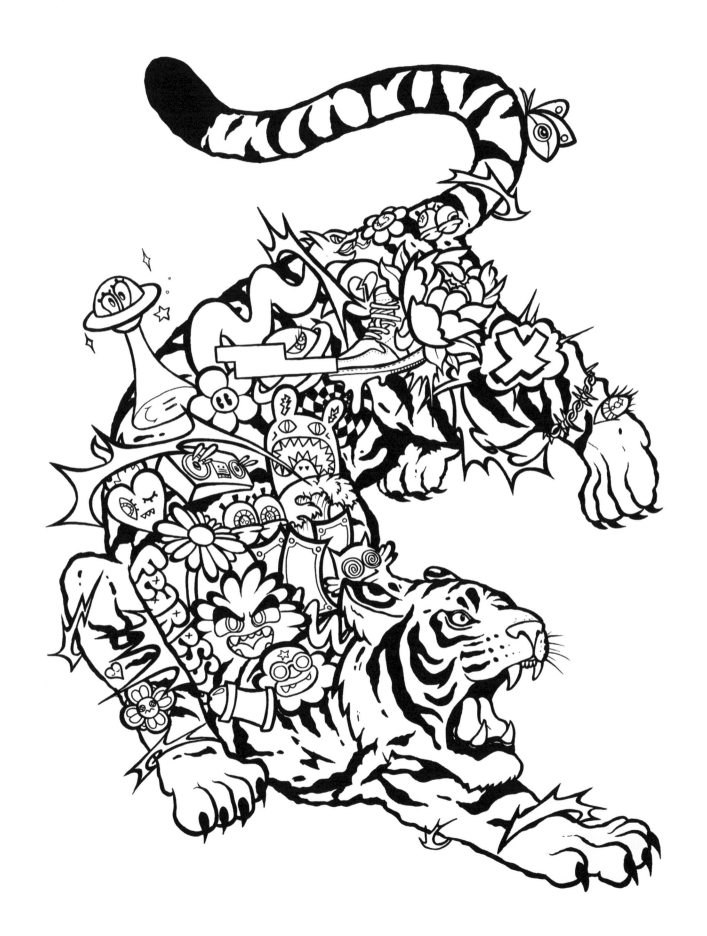

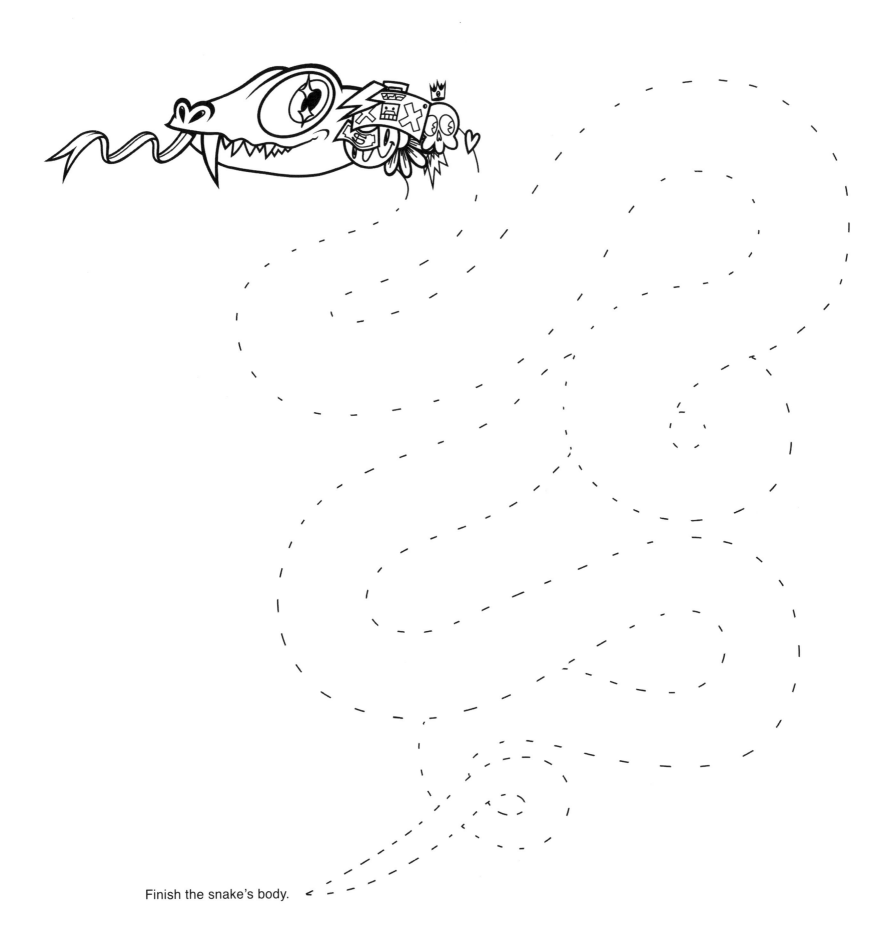

Finish the snake's body.

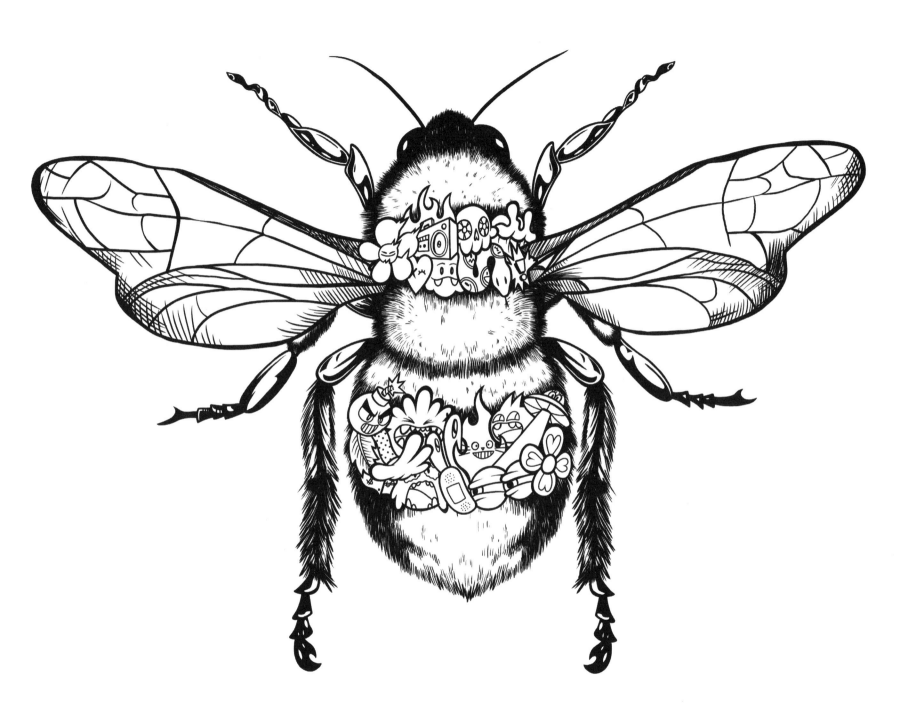

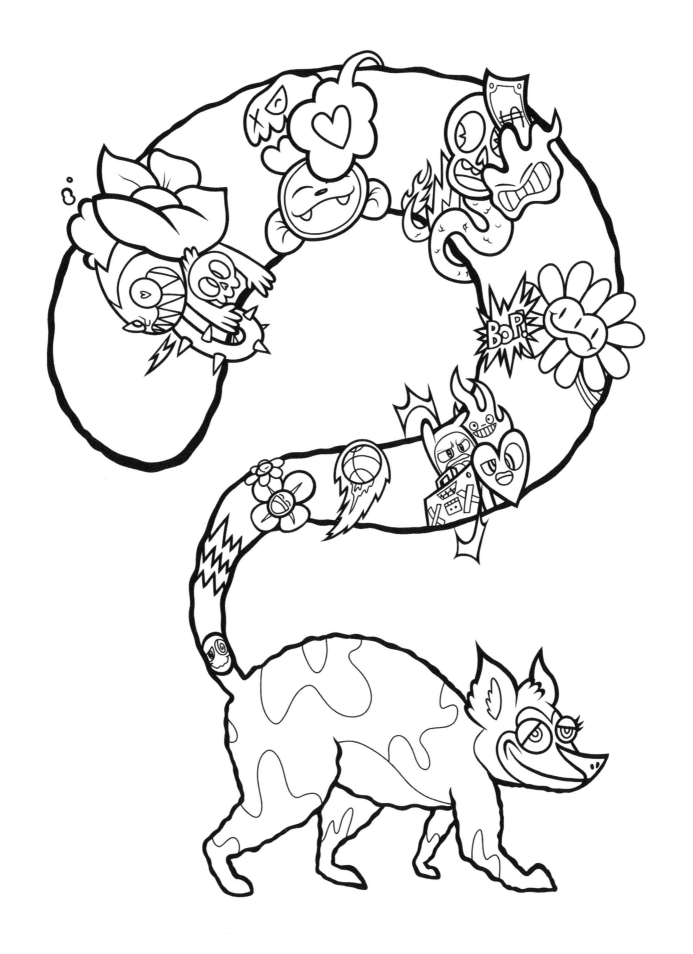

Complete the second gecko.

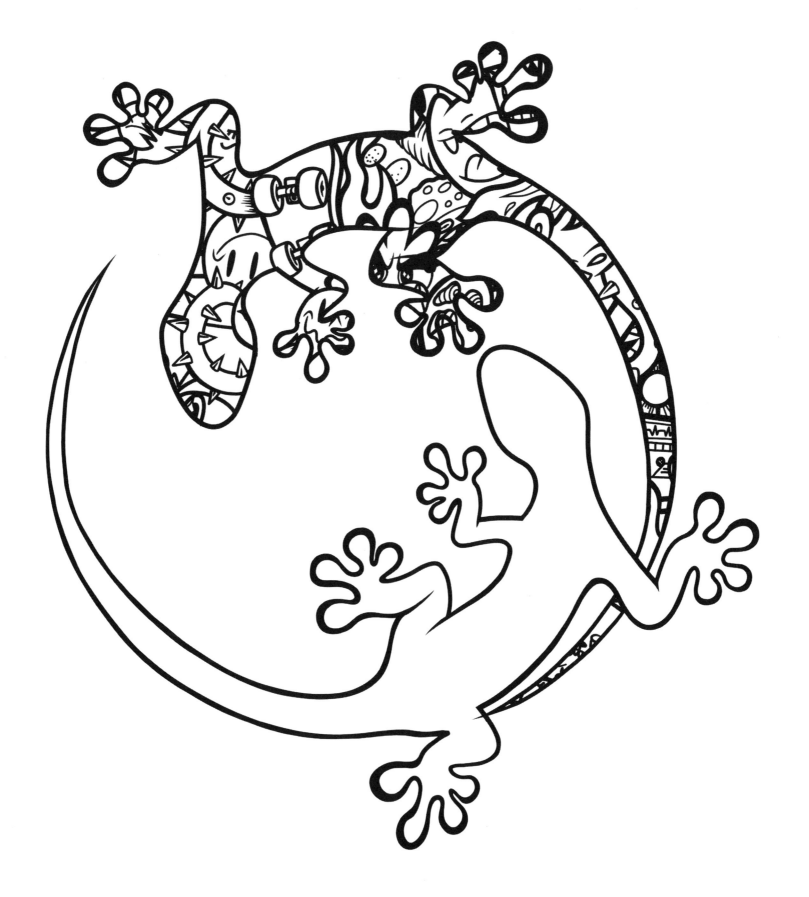

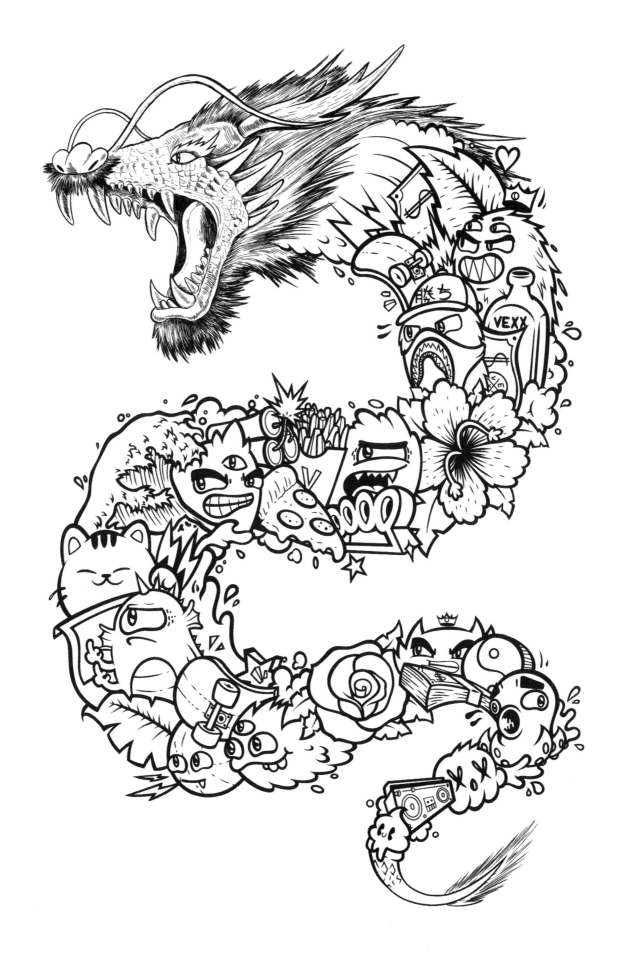

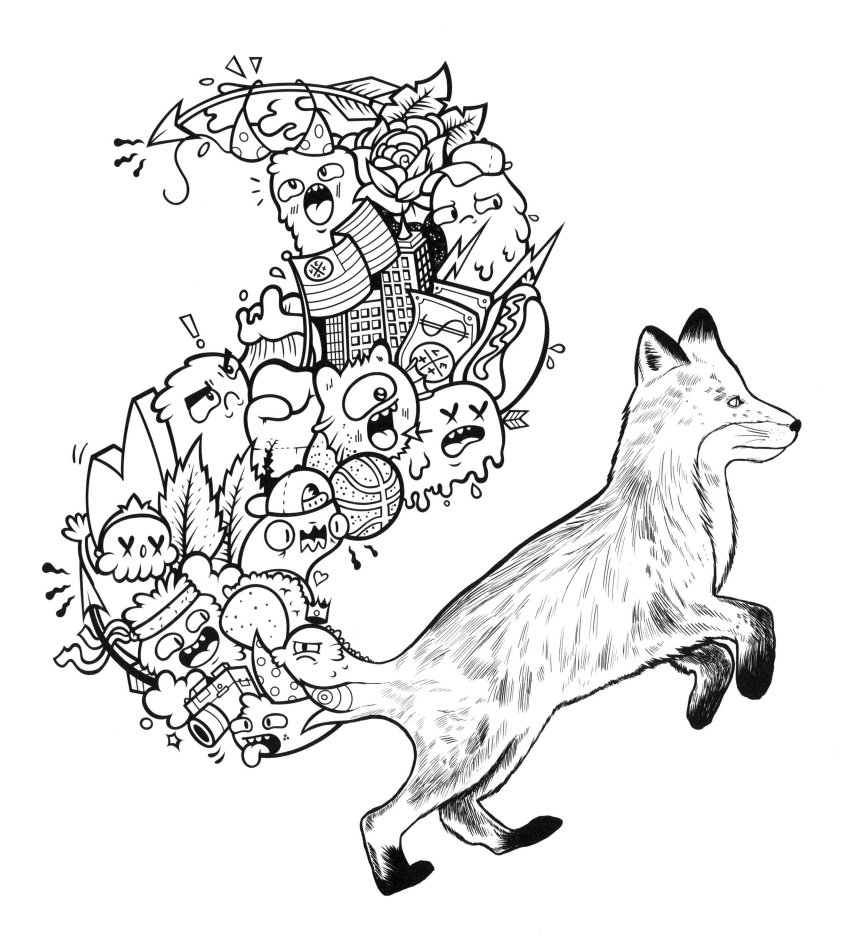

Decorate the snail's shell.

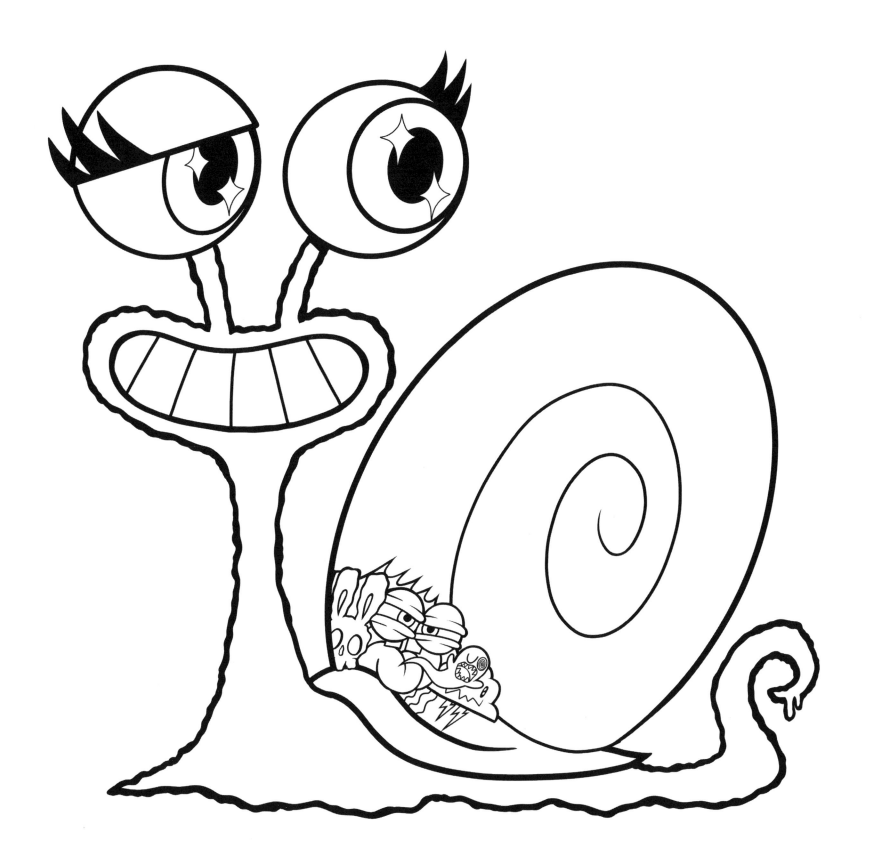

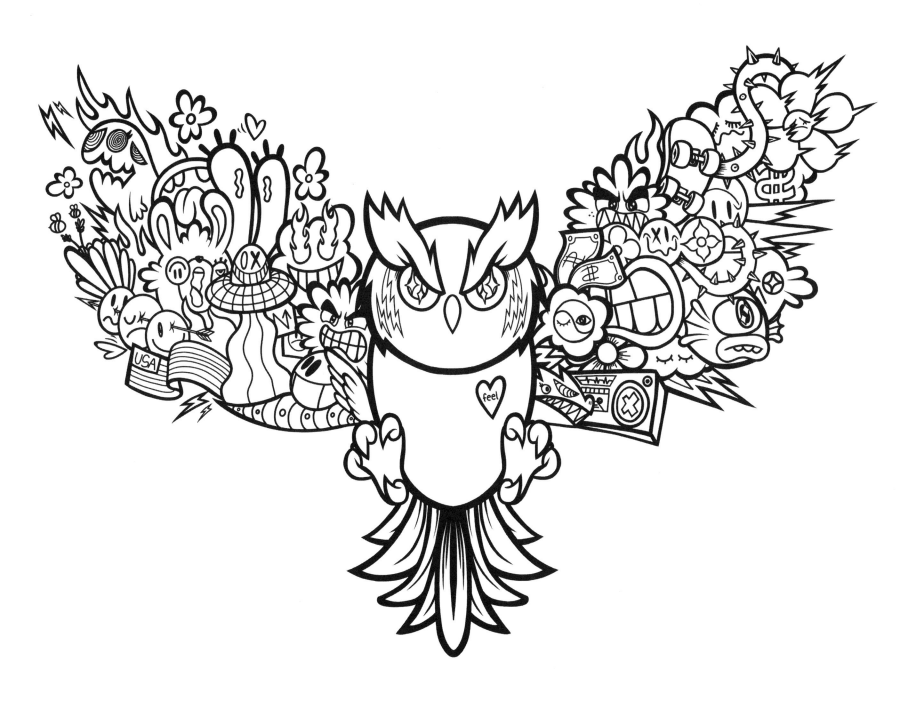

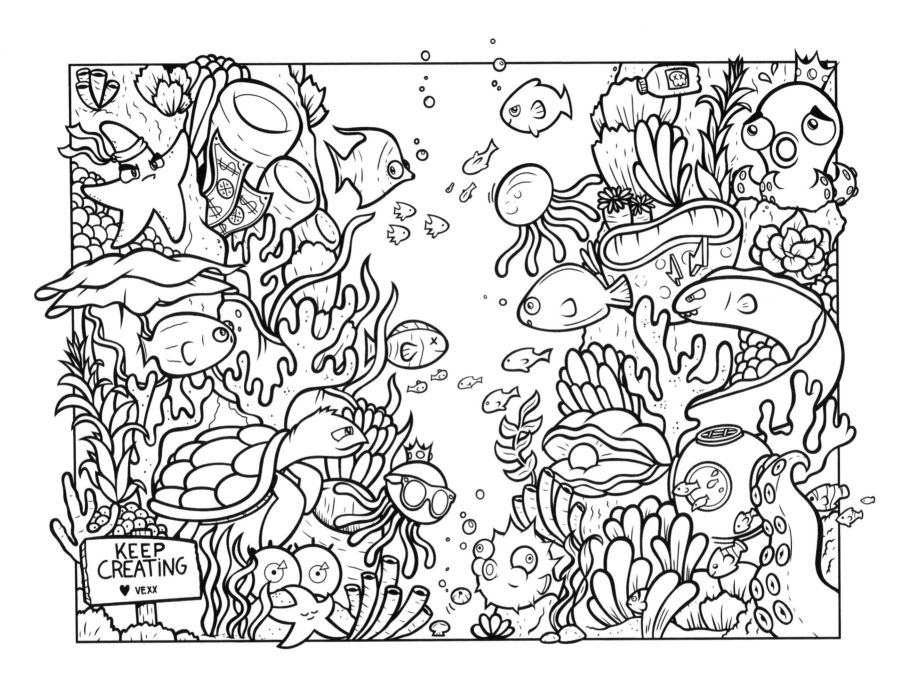

Create the second antler.

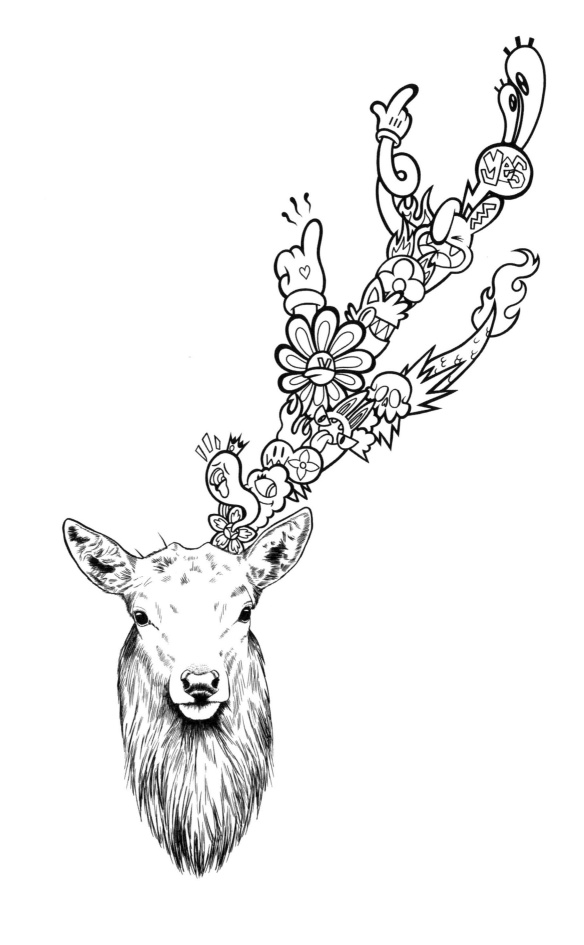

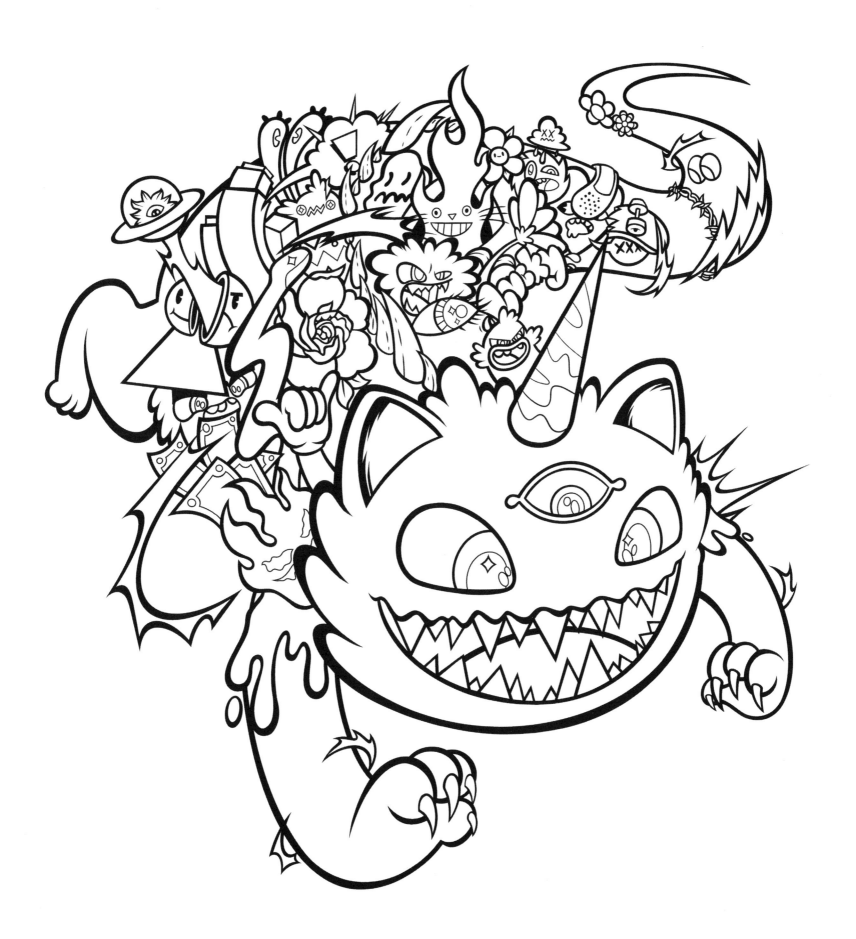

Complete the zebra's stripes.

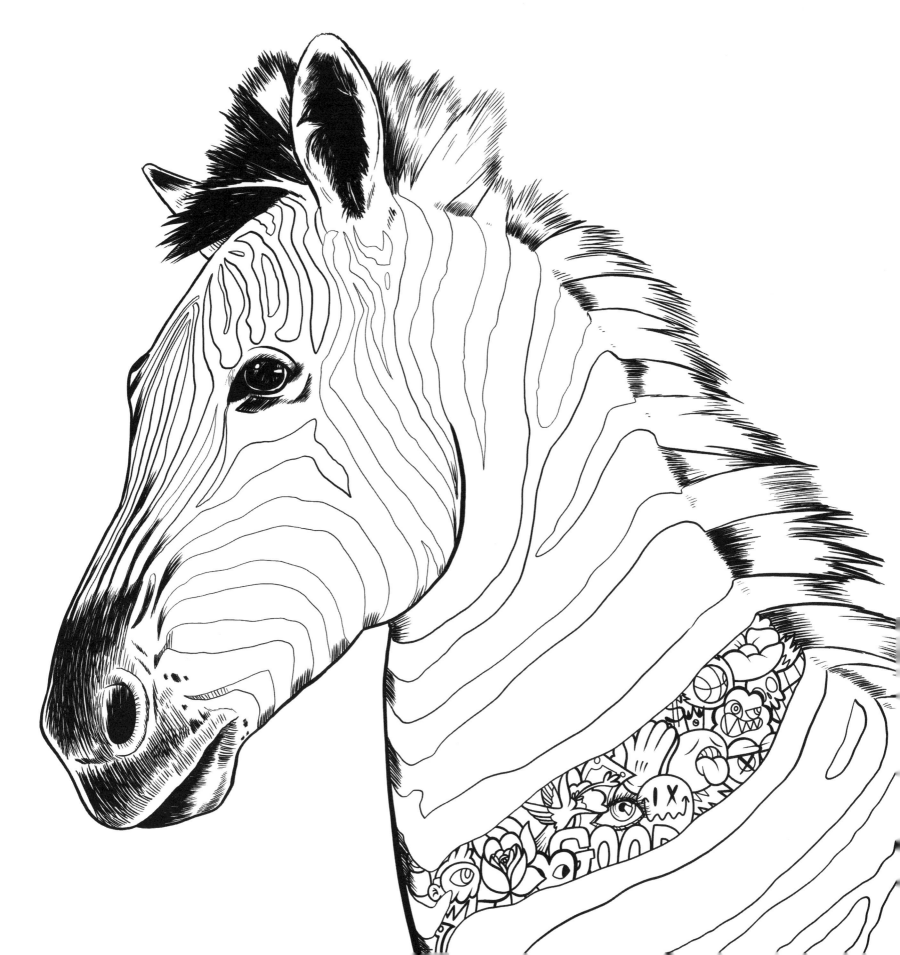

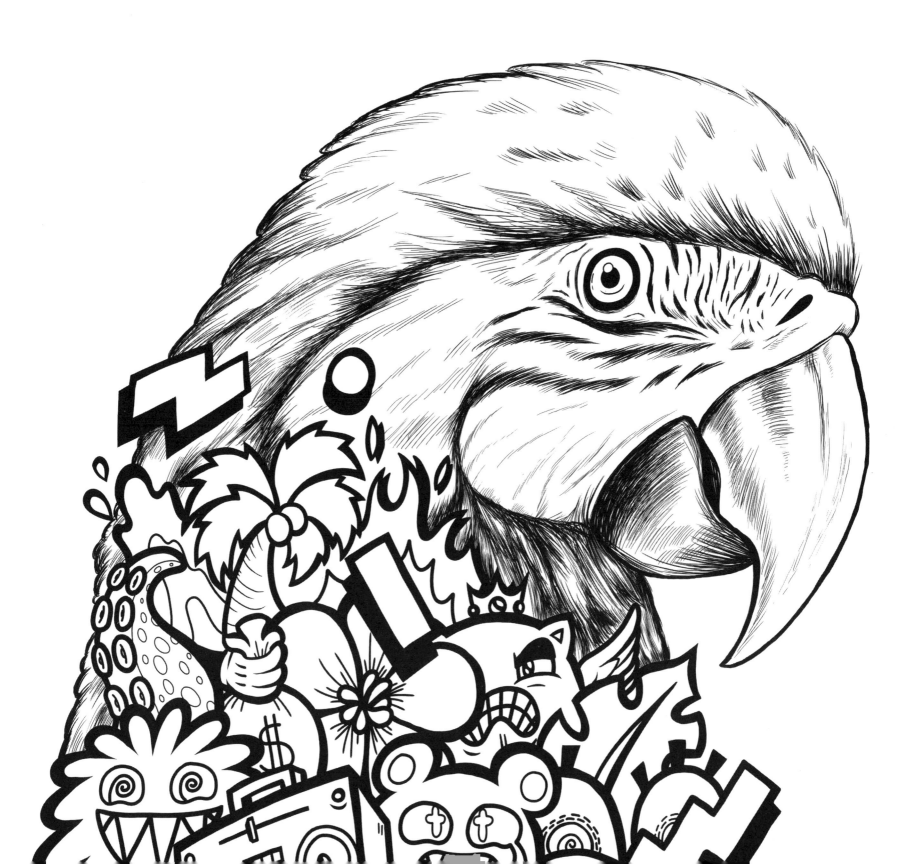

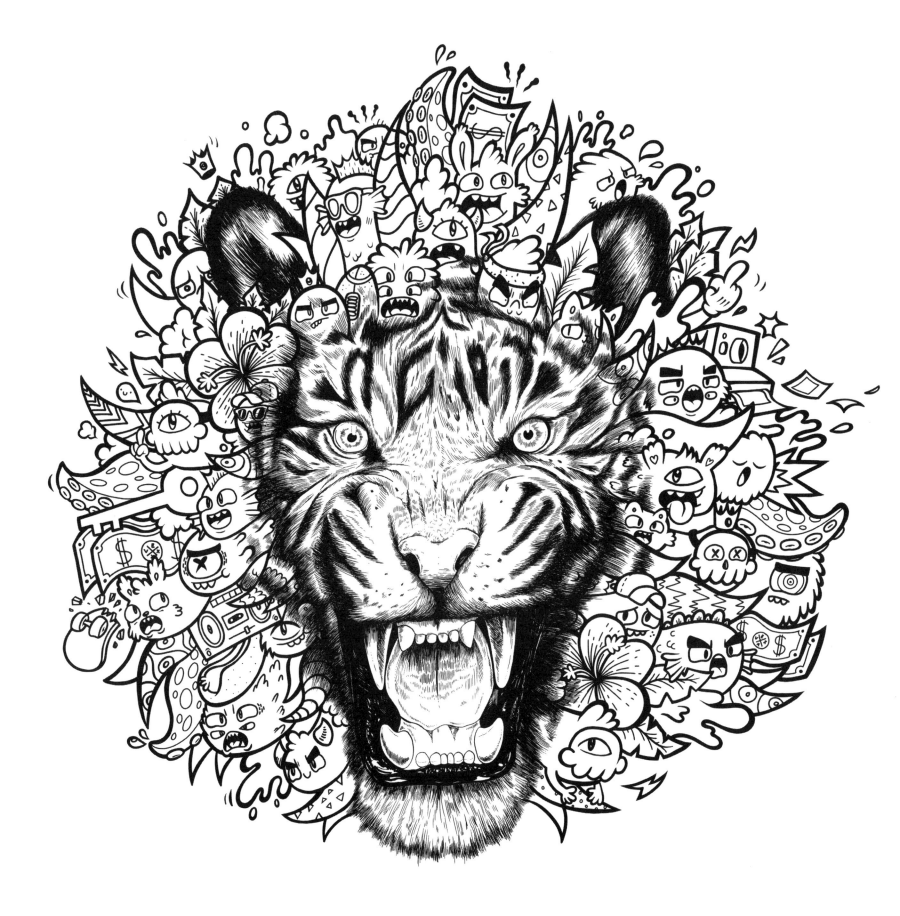

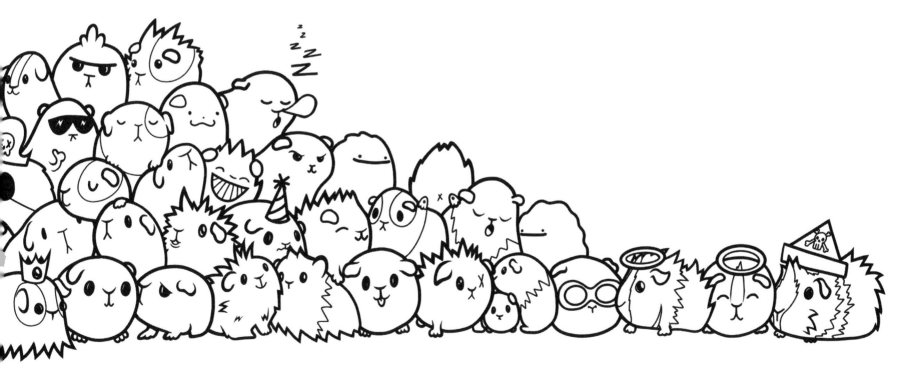

Fill the page with guinea pigs.

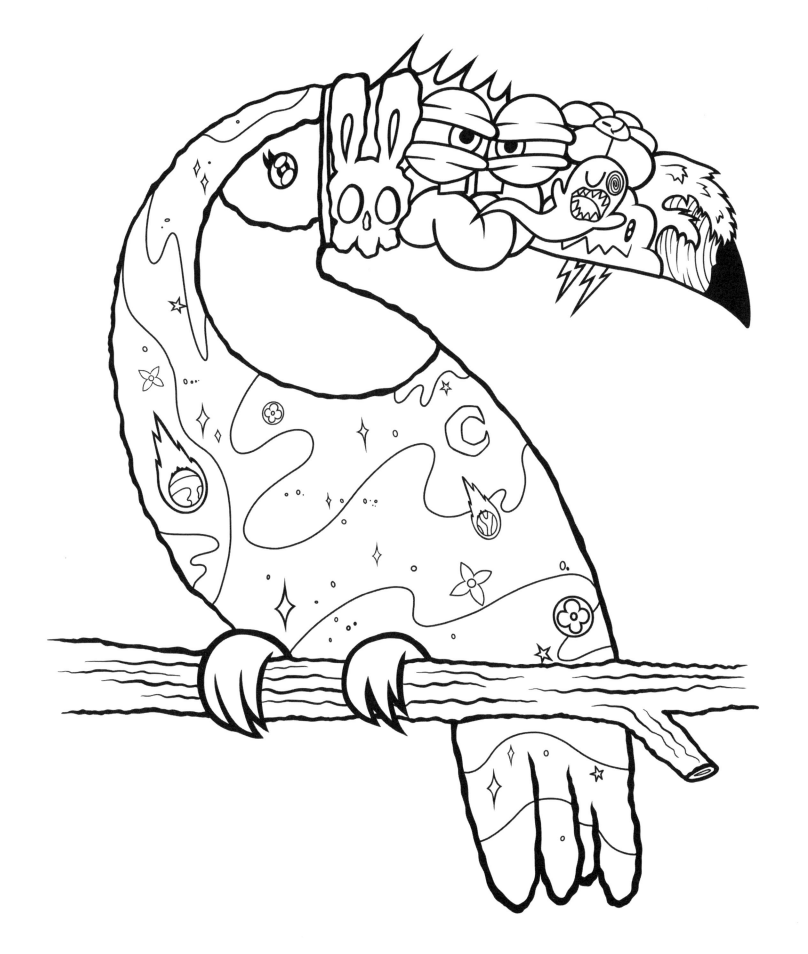

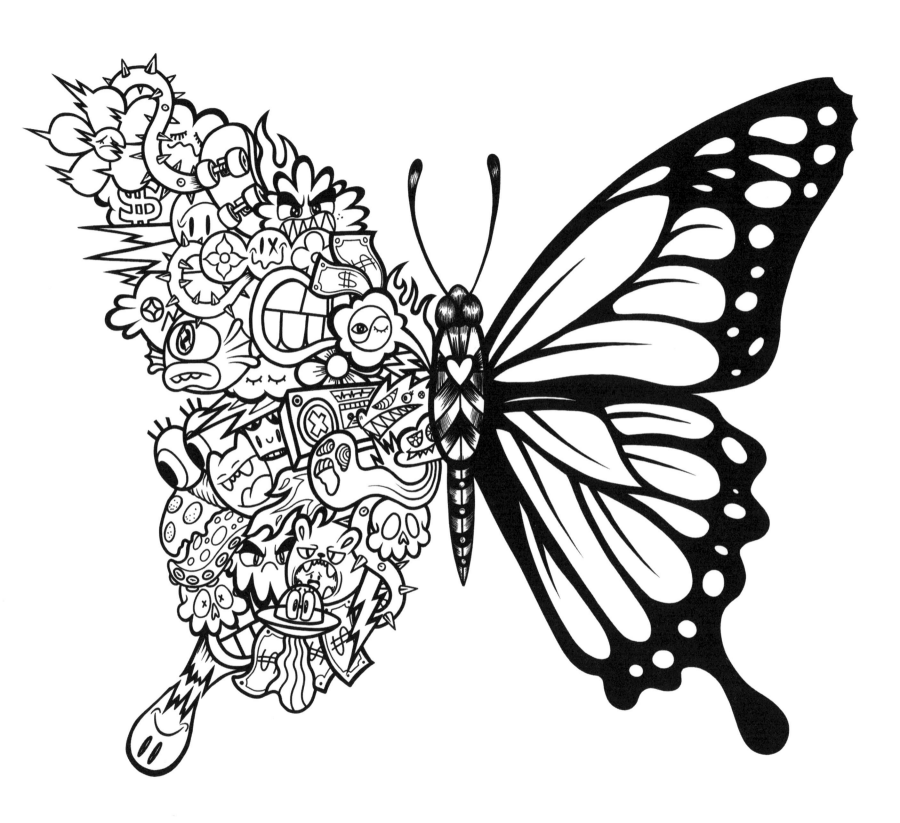

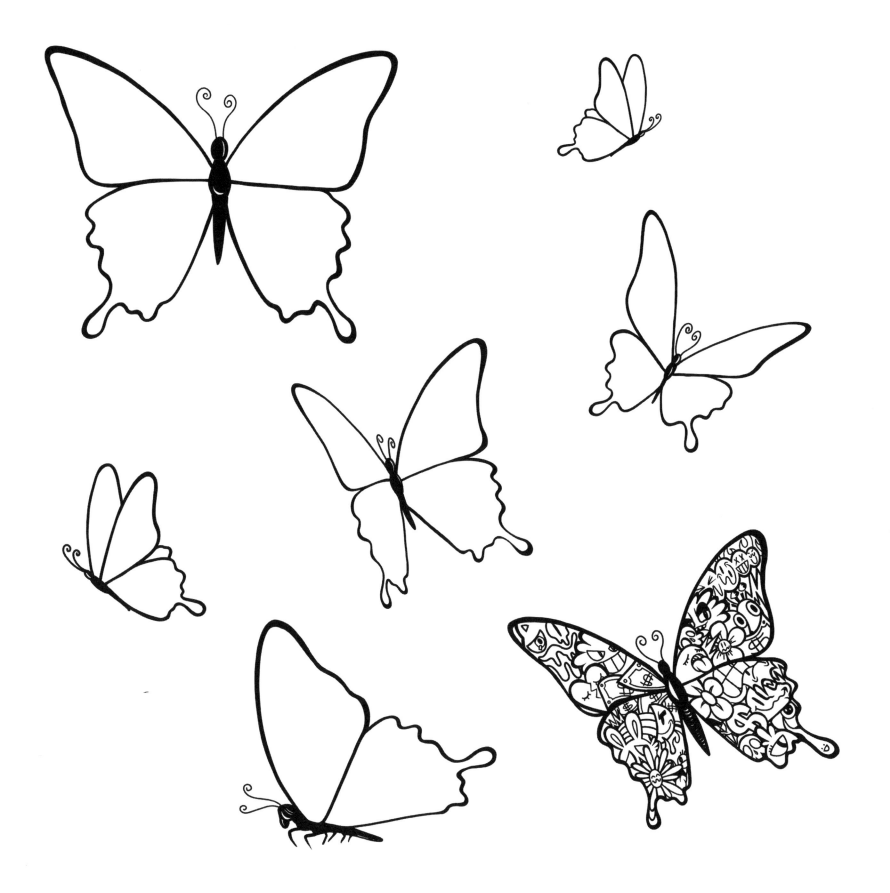

Doodle in the butterflies.

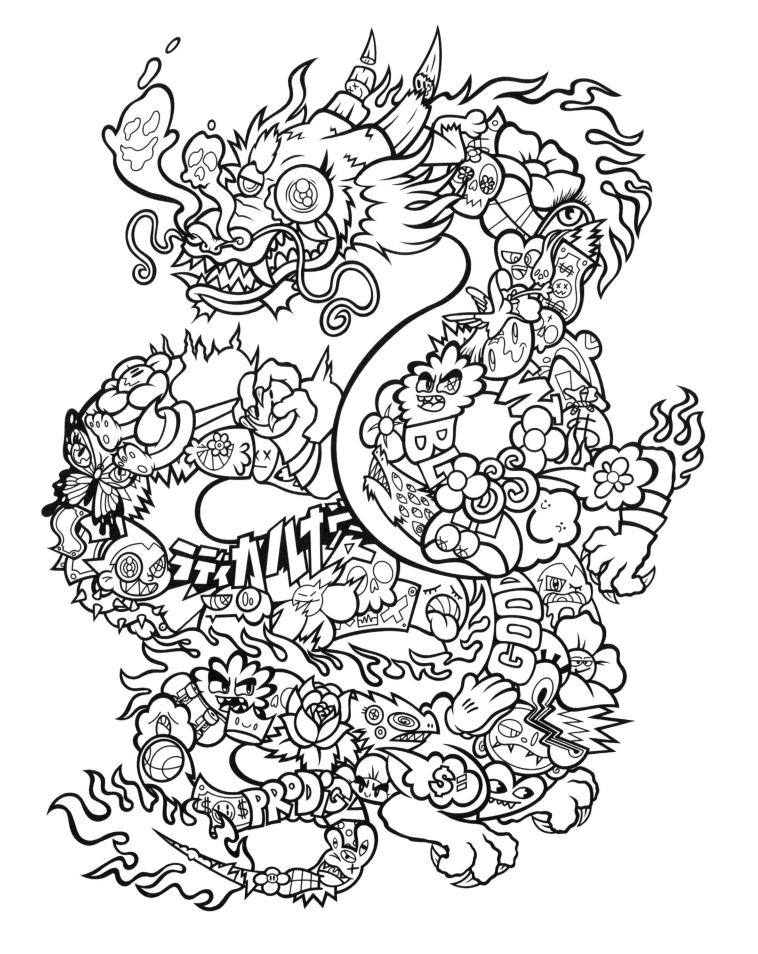

Complete the tiger's body with doodles.

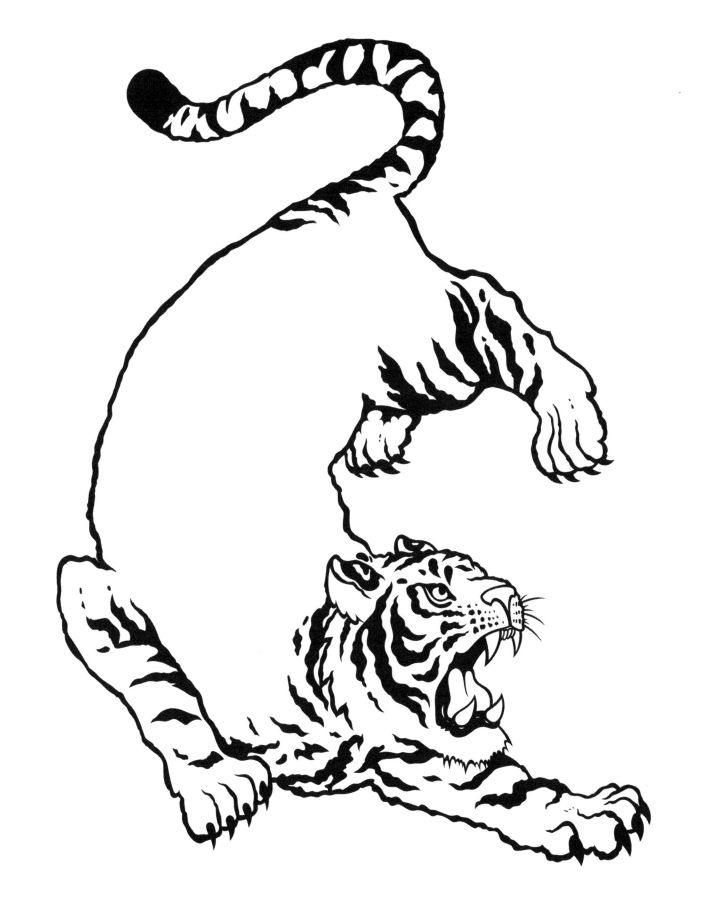

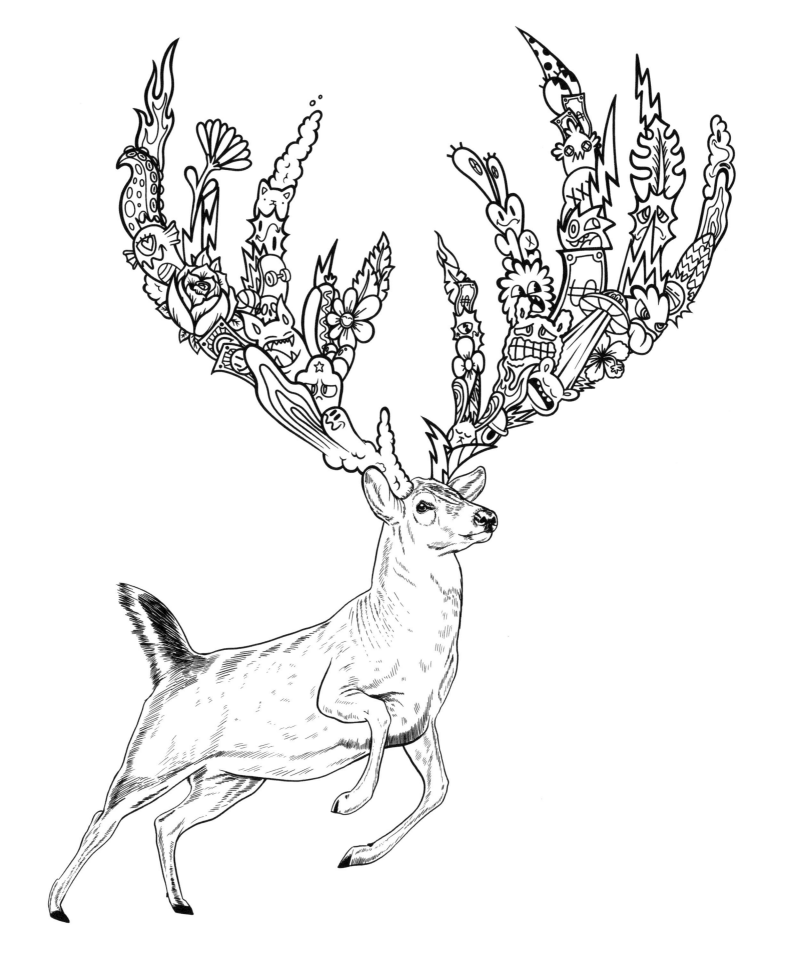

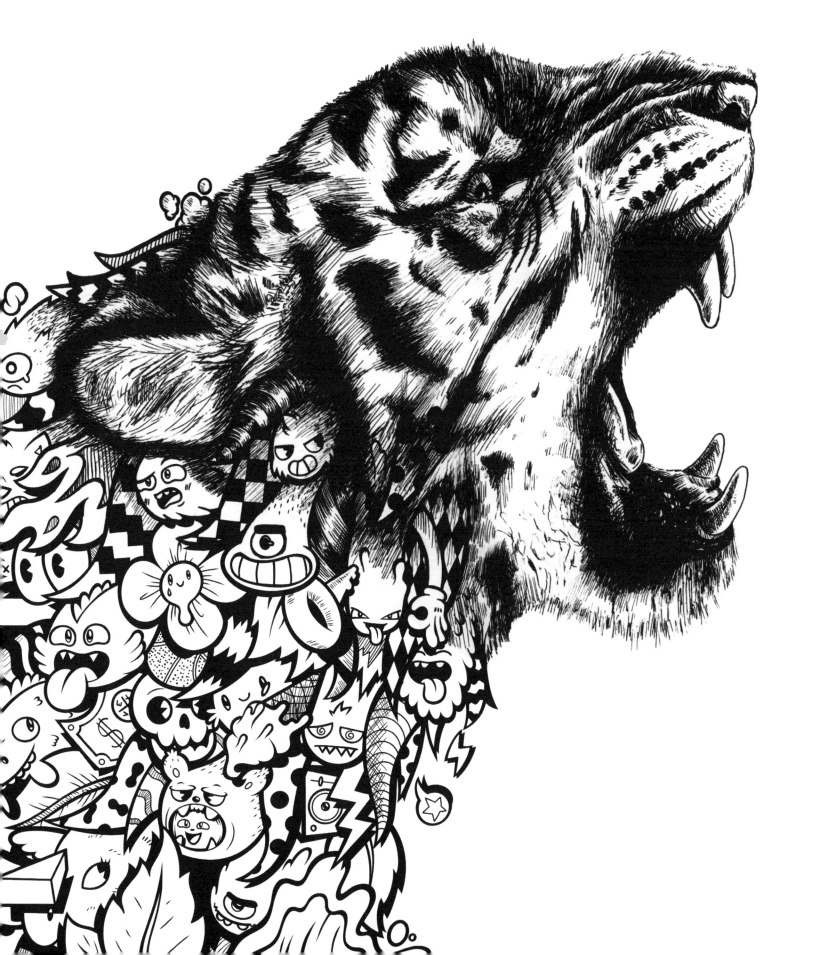

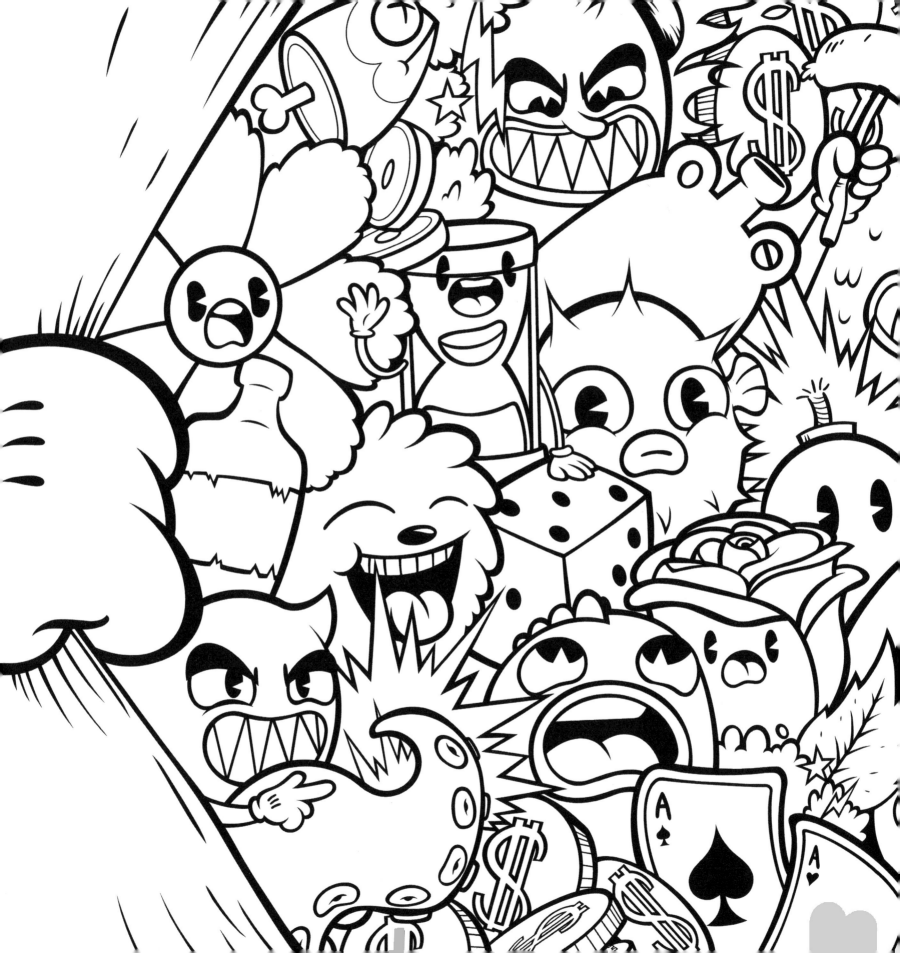

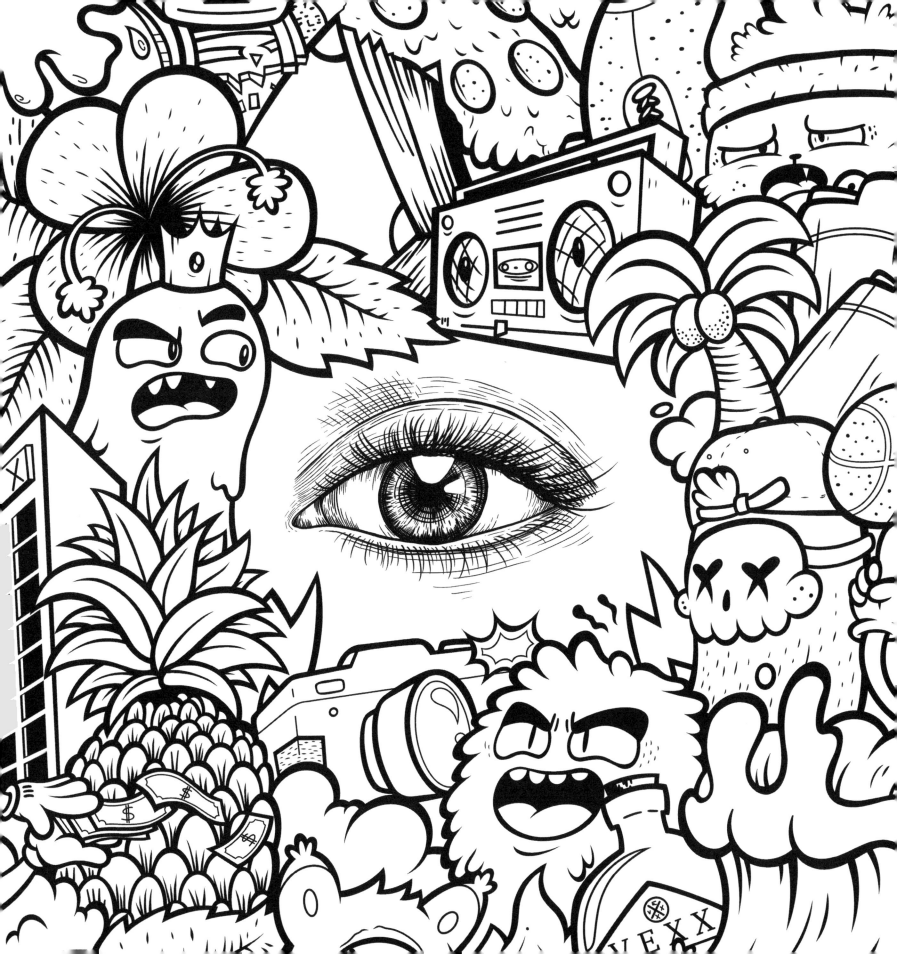

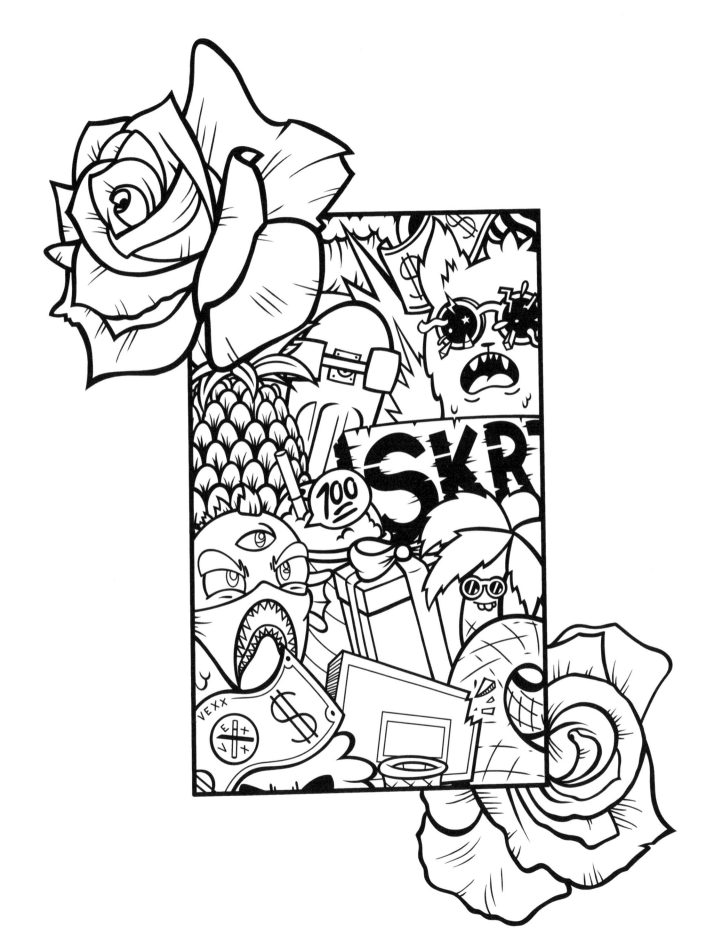

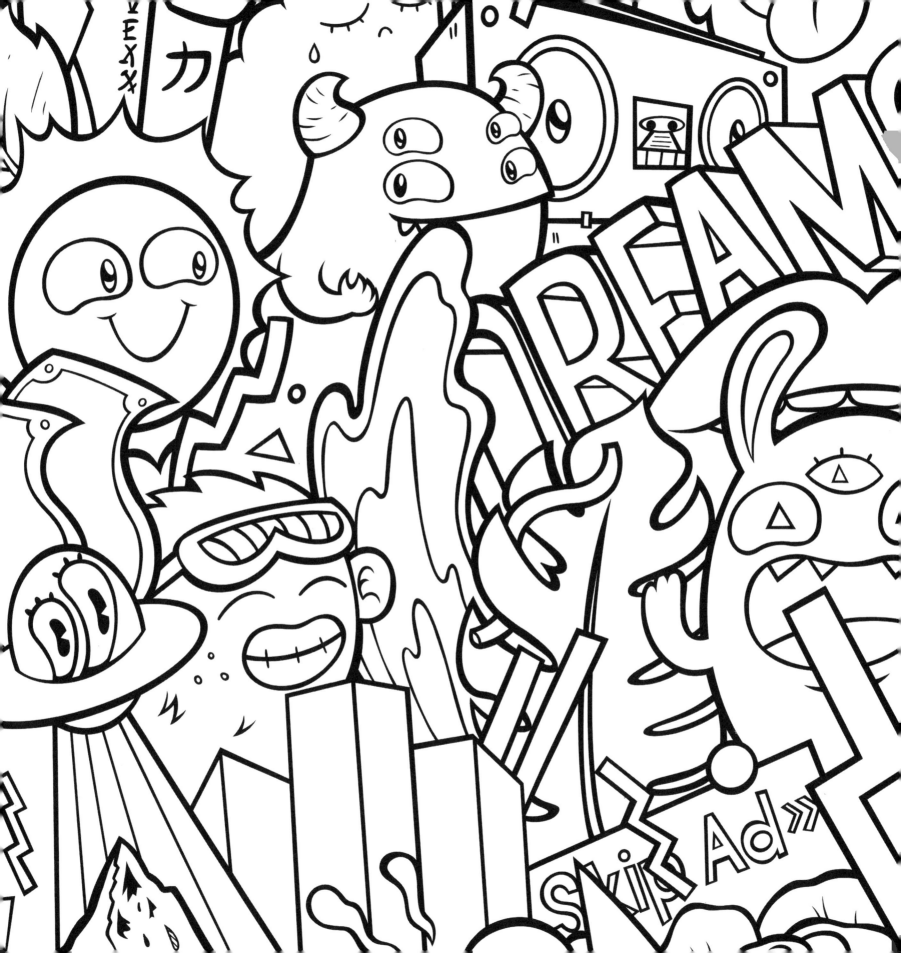

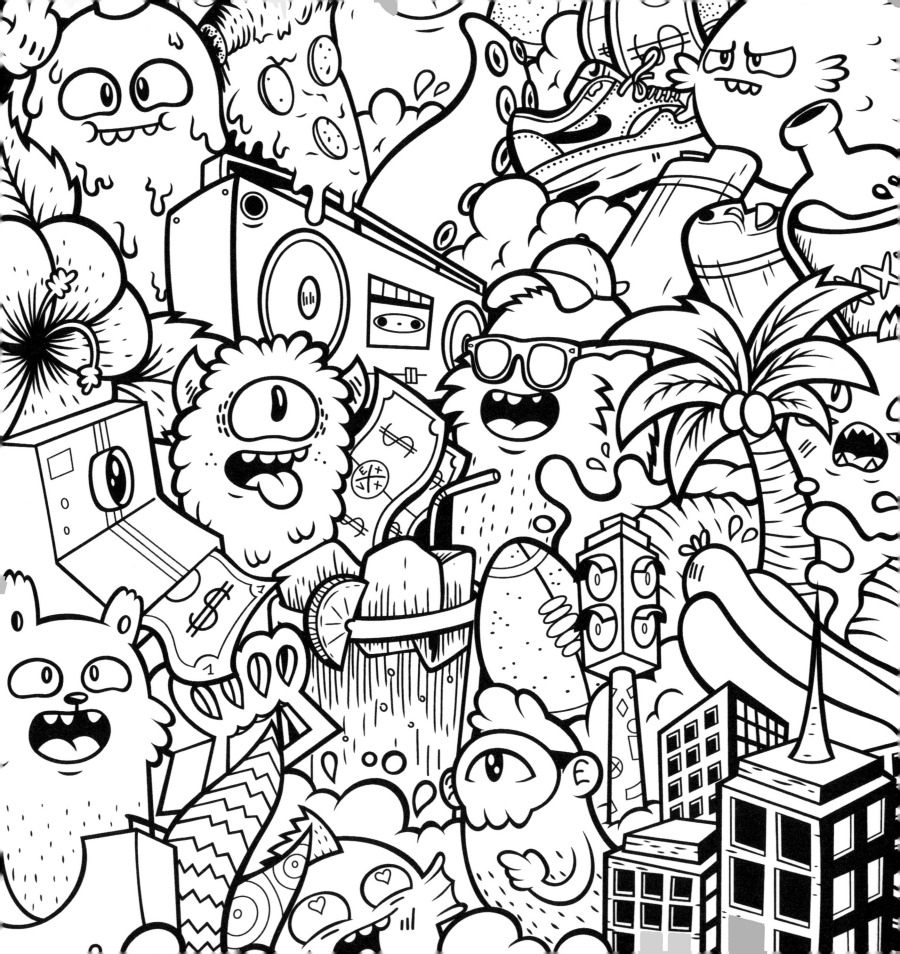

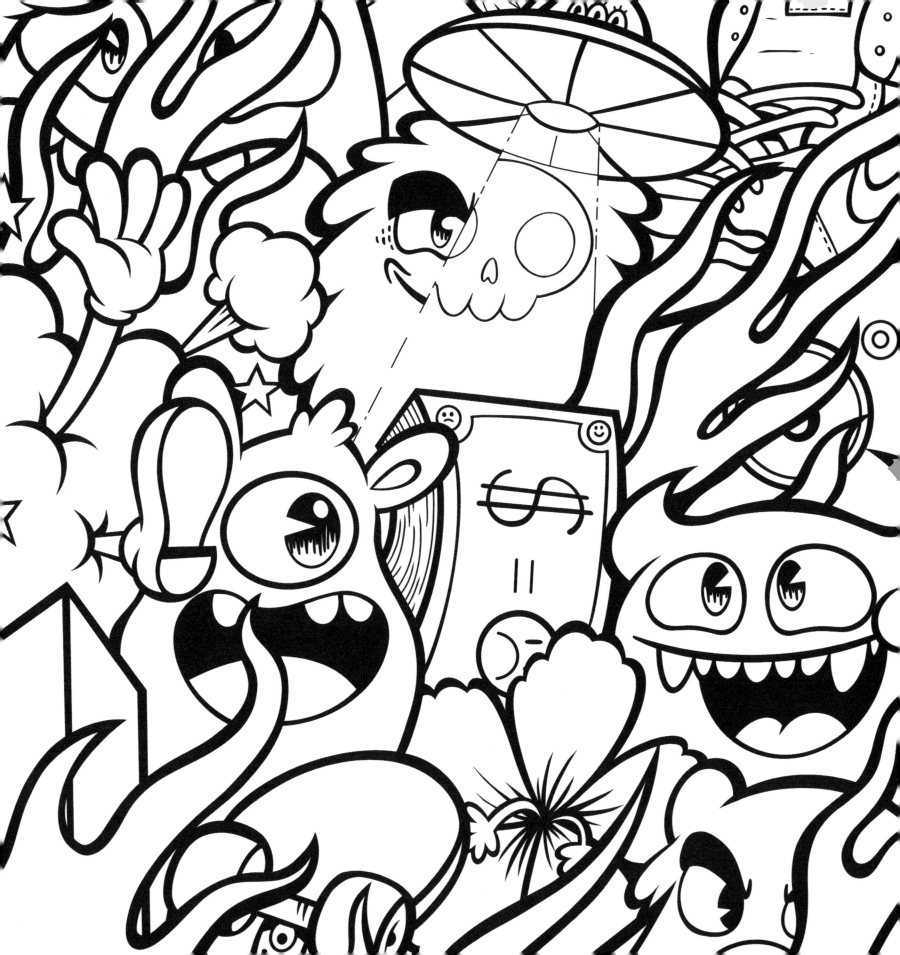

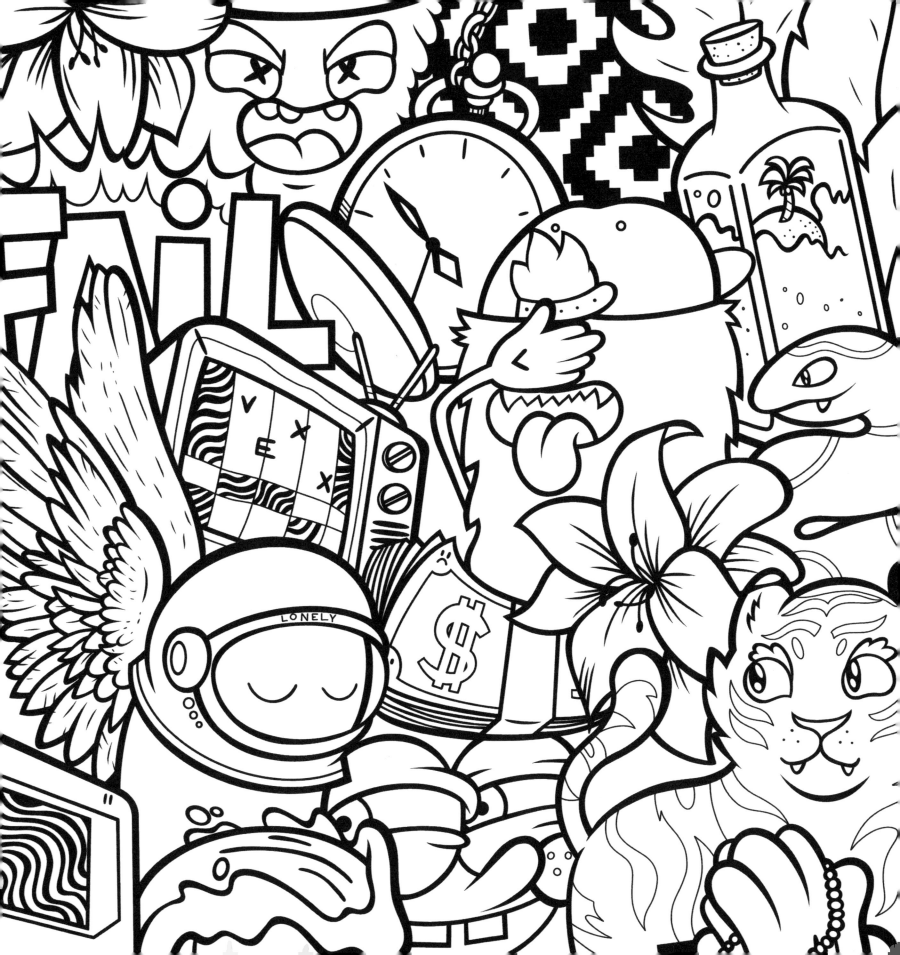

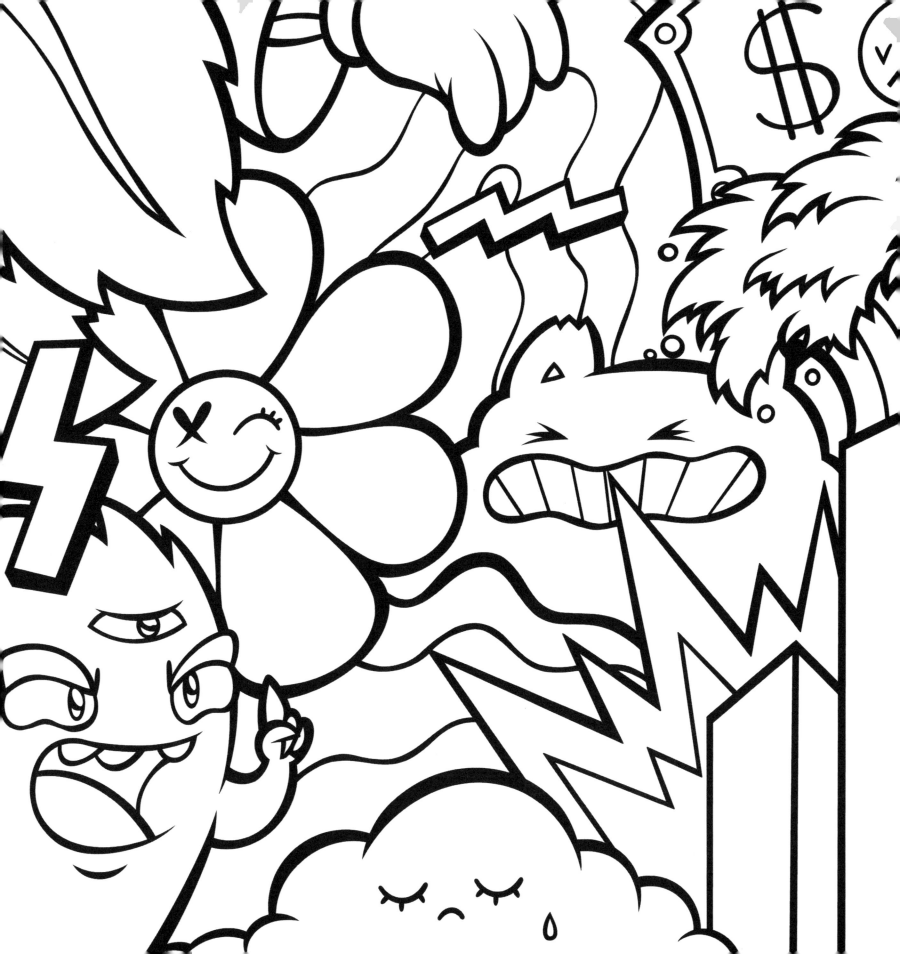

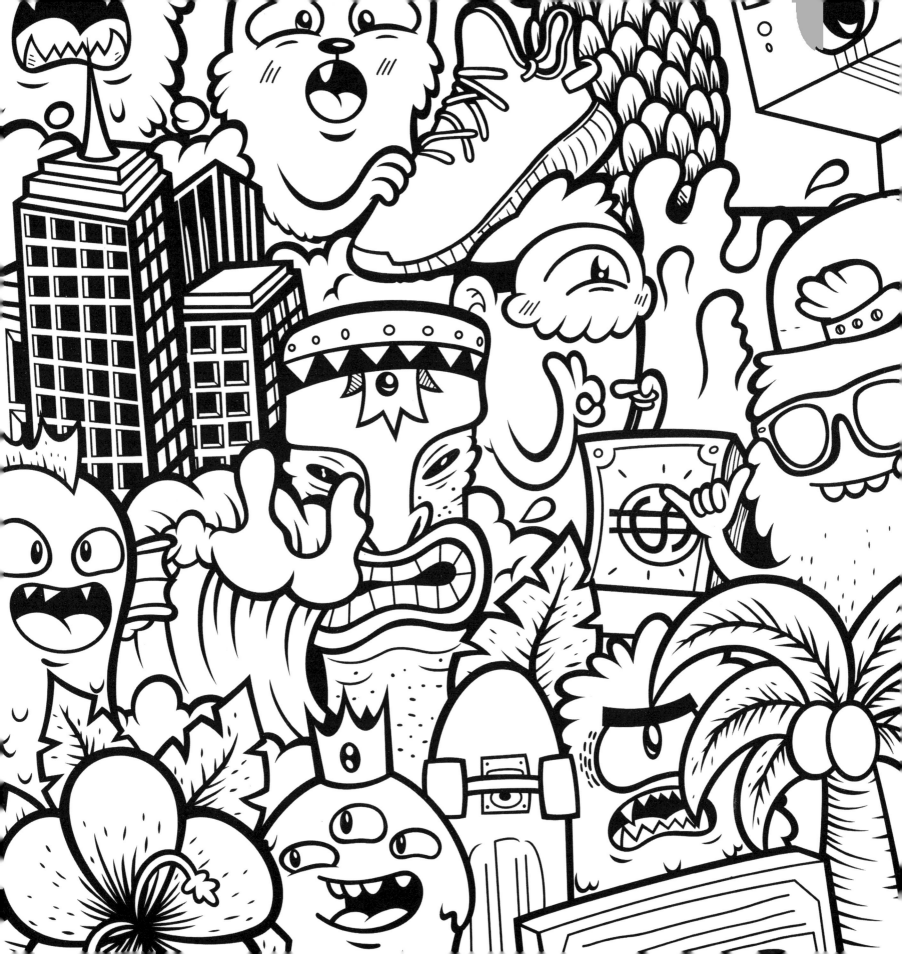

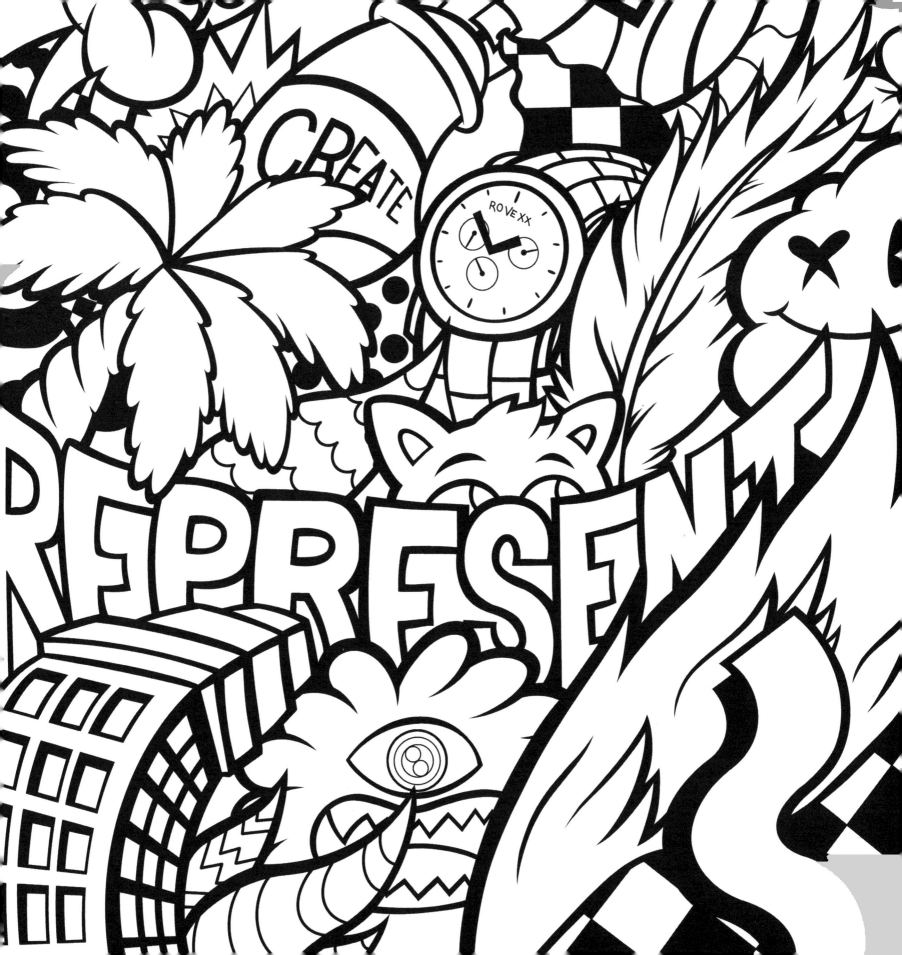

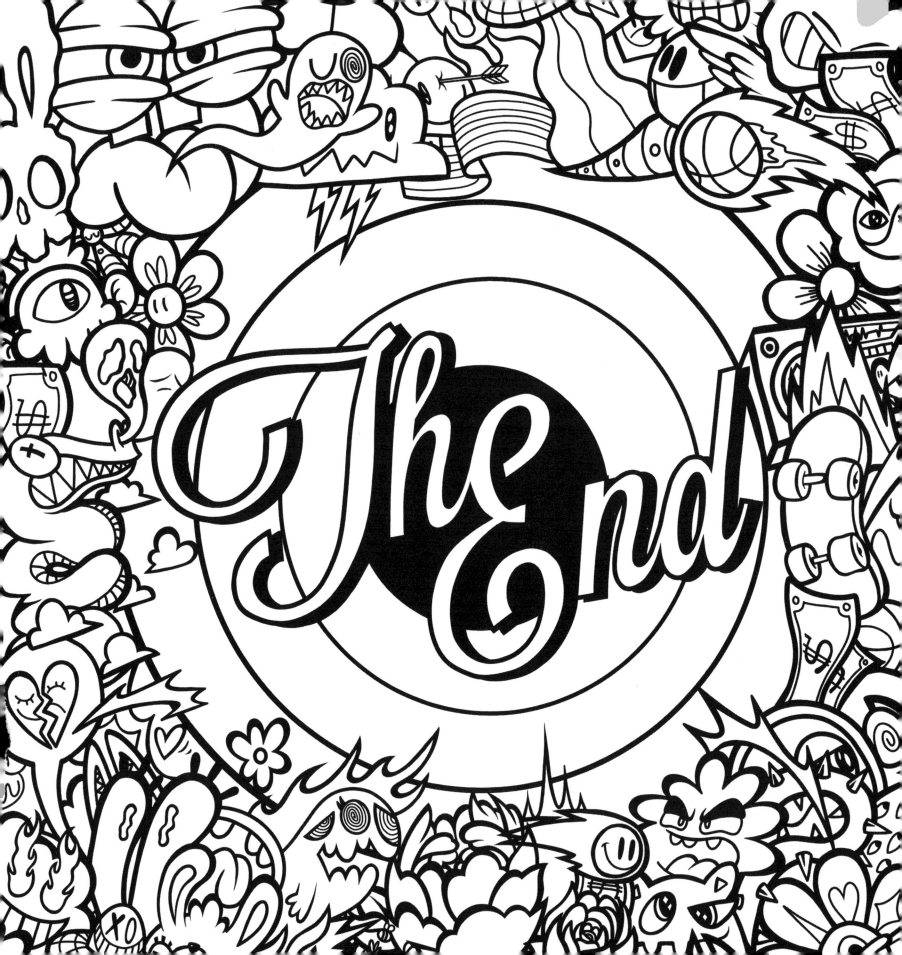

I hope you enjoyed this book, and I hope it inspires you to create!

I want to thank my fans for always supporting me and the stuff I make.

Thanks to Kevin Klein for being a great manager.

Thanks to Lauren Appleton for making this book a reality.

And thanks to Hypey for being a trusted helper during the making of this book.

Share your Creatopia artwork with me! I'd love to see your creations, and I'll be sharing some of my favorite ones.

Keep creating.

—VINCE

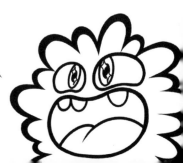

Creatopia

A COLORING BOOK

SHARE YOUR CREATIONS USING #CREATOPIA AND TAG @VEXX